Secrets to Drawing Realistic Faces

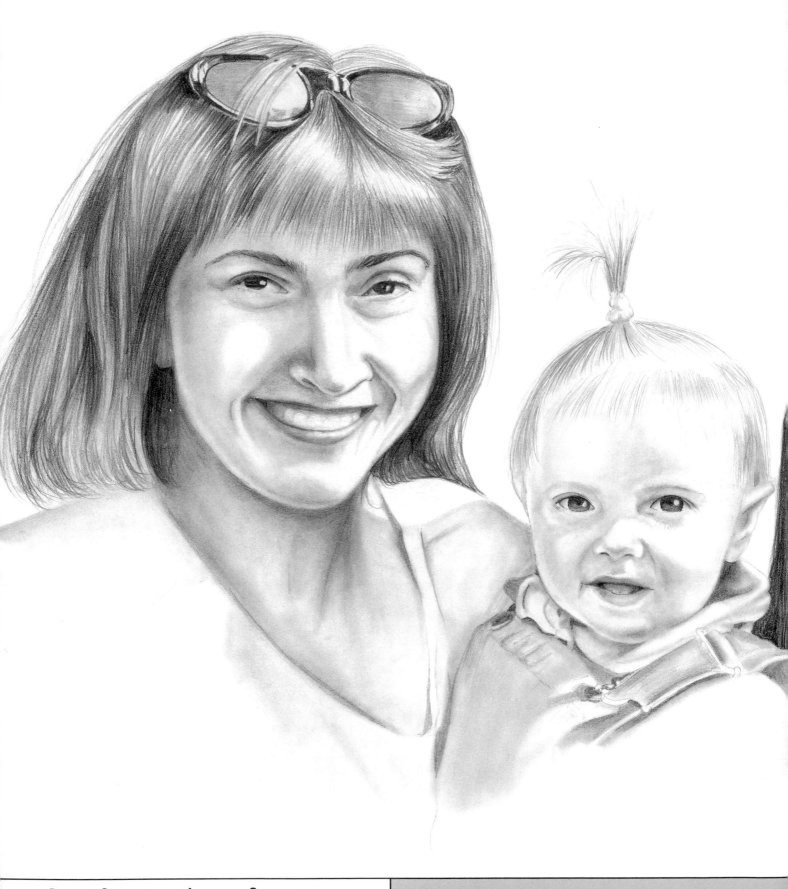

DIANA, SHILOH AND AYNSLEE STUART
11" × 14" (28cm × 36cm)

secrets to
DRAWING
REALISTIC
FACES

CARRIE STUART PARKS

NORTH LIGHT BOOKS
CINCINNATI, OHIO
www.artistsnetwork.com

CARRIE STUART PARKS is an award-winning watercolorist and internationally known forensic artist and instructor.

In 1981, Carrie began working as a part time forensic artist for the North Idaho Regional Crime Lab in Coeur d'Alene, Idaho. Four years later she attended a composite drawing class taught by the FBI, and became the first composite artist in her area. Soon Carrie's peers were asking her to share her knowledge with them. Carrie developed a sure-fire and condensed instructional course to teach anyone—whatever age or skill level—how to create realistic portraits.

Carrie and her husband, Rick, travel across the nation teaching composite drawing courses to FBI and Secret Service agents, law enforcement agencies and civilian adults and children. Carrie has won numerous awards for excellence for her instruction and general career excellence.

Carrie's strikingly realistic composites have helped successfully identify and capture suspects across the country, including serial murders, rapists, white supremacists and bombers. Carrie's composites have also been featured on *America's Most Wanted* and *20/20*.

Rick and Carrie (Stuart) Parks reside on a 680-acre ranch in North Idaho where Carrie grew up. You may contact her by e-mail at banjoart@imbris.net or at her Web site http://www.stuartparks.com

Other fine North Light Books are available from your local bookstore, art supply store or direct from the publisher.

11 10 09 08 12 11 10

Library of Congress Cataloging-in-Publication Data
Parks, Carrie
 Secrets to drawing realistic faces / Carrie Stuart Parks.— 1st ed.
 p.cm.
 Includes index.
 ISBN-13: 978-1-58180-216-0 (alk. paper)
 ISBN-10: 1-58180-216-1 (alk. paper)
 1. Face in art. 2. Drawing—Technique. I. Title.
 NC770 .P285 2002
 743.4'2—dc21 2002023509

Editors: Mike Berger and Bethe Ferguson
Designer: Wendy Dunning
Production Coordinator: Mark Griffin

F+W PUBLICATIONS, INC.

Metric Conversion Chart

to convert	to	multiply by
Inches	Centimeters	2.54
Centimeters	Inches	0.4
Feet	Centimeters	30.5
Centimeters	Feet	0.03
Yards	Meters	0.9
Meters	Yards	1.1
Sq. Inches	Sq. Centimeters	6.45
Sq. Centimeters	Sq. Inches	0.16
Sq. Feet	Sq. Meters	0.09
Sq. Meters	Sq. Feet	10.8
Sq. Yards	Sq. Meters	0.8
Sq. Meters	Sq. Yards	1.2
Pounds	Kilograms	0.45
Kilograms	Pounds	2.2
Ounces	Grams	28.3
Grams	Ounces	0.035

DEDICATION

*This book is dedicated to the memory of
my dad, Edwin Zaring Stuart ("Ned"),
and to the everyday heroes in our lives.*

ACKNOWLEDGMENTS

I feel like I should say thank you to every person I have ever met. However, if I indulged this idea there would be no room for the rest of the text in this book. Instead, I'll try to concentrate on the folks who made this possible, and I hope that the rest of the world will understand. The level of my gratitude is not to be measured by the location or order of the names.

I am indebted to North Light Books, starting with Rachel Rubin Wolf, who gave me the chance to write this book. I am so grateful that she opened the door. Thank you to Michael Berger, who first made sense of it all, and to Bethe Ferguson and the rest of the staff who will bring this book into focus.

Once again, I thank the many people listed in the back of the book for their wonderful art and beautiful faces.

I thank my mom and dad for a lifetime of love and encouragement. I thank my "big" brother, Steve, and his wife Diana and daughter Shiloh for their patience. I thank my "little" brother, Scott and his gracious family, Laurie, Jeff, Bentley and Aynslee for putting up with my camera in their faces for years (smile for Aunt Carrie). I thank Don Parks for his caring and the gift of my wonderful husband, Rick. I thank Donna, J.B. Cole, Skylar and Cortney Lindsey for their continuing love.

To the many people over the years who supported us by letting us into their homes and hearts, a deeply felt thank you is long overdue; for Boyd and Cindy Bryant, Kami and Gerry Hines, Aida and Jim Remele, Kathy and Bob Gonzales, Debbie and Pat Torok, Ed Jany, Jim and Cathy Champion, Toni Redding and Norma Shepherd.

I thank my dear friends Frank and Barbara Peretti for their personal and artistic inspiration and love over the years. I am truly, eternally grateful.

The best for last—I thank my wonderful husband, Rick, for his constant love, patience, friendship and artistic inspiration.

Most of all, I thank the Lord Jesus for his blessings and grace.

TABLE OF CONTENTS

INTRODUCTION 8

1 Looking the Part: Materials and Supplies *12*

Pencils and Erasers • Other Tools

2 The Problem *18*

Why is Drawing so Hard? • Natural Artists

3 Site *28*

SITE TOOL: Measuring • SITE TOOLS: Flattening and Optical Indexing

4 Shape *42*

Train Your Mind • SHAPE TOOL: Isolate • SHAPE TOOLS: Simplify and Relate • SHAPE TOOL: Measure • SHAPE TOOL: Invert • SHAPE TOOLS: Rename and Incline • SHAPE TOOL: Negative • SHAPE TOOL: Question • SHAPE TOOL: Compare • SHAPE TOOL: Flatten

5 Shade *58*

Understanding Shade Tools • SHADE TOOL: Values/Lines • SHADE TOOLS: Isolate, Squint and Compare • SHADE TOOL: Question • SHADE TOOL: Seek • Accuracy-Checking Techniques

6 Drawing Eyes *76*

Eyes as Shapes • Centering • Relate • Eyelid Creases • Shading and Filling the Eye • Eyebrows and Eyelashes

7 Drawing Noses *94*

The Nose as a Shape • Nose Site • Wing Site • Basic Wing Shape • Nostril Basics • Nostril Shapes • Nose Tricks

8 Drawing Lips and Teeth *106*

Parts of the Mouth • Shading the Mouth • Dealing with Teeth

9 Drawing the Head *116*

The Structure of the Head • Head Shapes • Cheeks • Chins • Necks • The Female Face • Child vs. Adult Head Shapes • Drawing Ears

10 Drawing Hair *132*

Creating Different Types of Hair • Different Hairstyles

CONCLUSION 141

INDEX 142-143

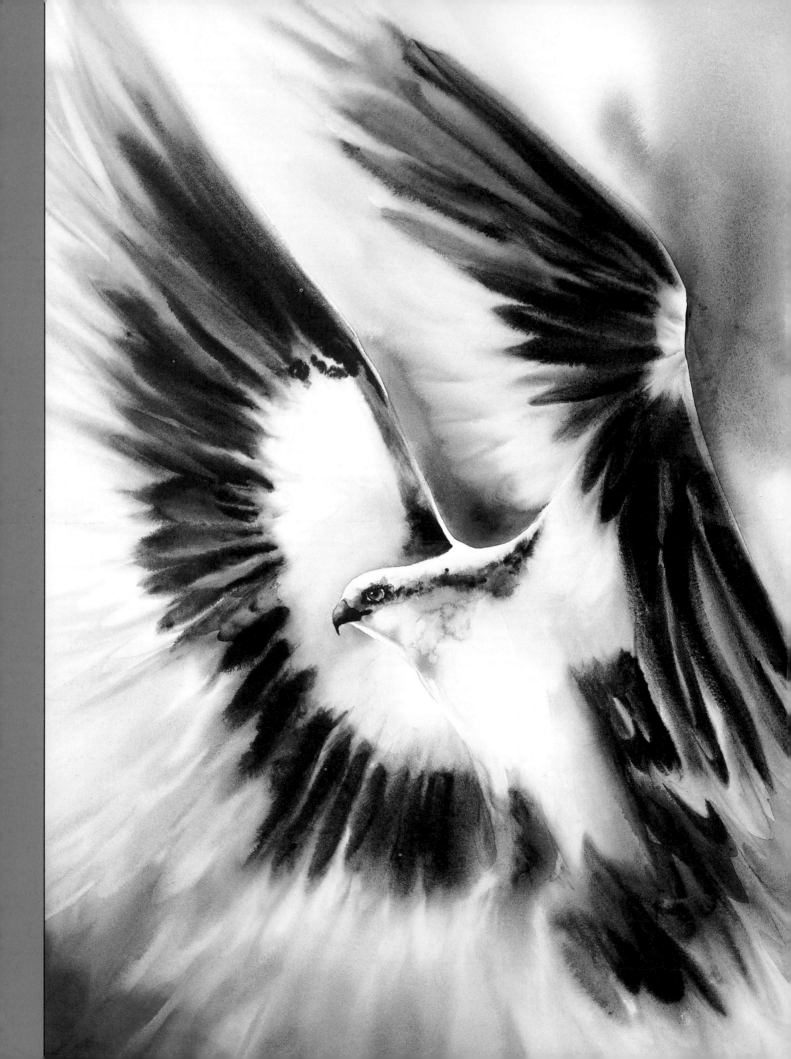

For the first ten years of my artistic career I only painted animals and used the wet-on-wet watercolor technique. I began painting birds, and they all had fur rather than feathers! I now use my bird paintings for competitions.

WINGS AS EAGLES
Watercolor
Collection of the Frame of Mind Gallery,
Coeur d'Alene, Idaho
28" × 22" (71cm × 57cm)

INTRODUCTION

You will quickly notice in this book that I approach drawing faces from a very different direction. It might be easier for you to understand if I share some of the roads I have traveled down to get here.

My background is similar to that of most artists. I was originally trained as a commercial artist in the days before computers did all the layout and lettering work. I would sit with my classmates and peer at a table full of junk that the instructor called a "still life." It was assumed that we knew what to look for and how to render it in charcoal or pencil. The professor would wander about the room and comment, or shudder, at our efforts. We were in the art department, which meant that we were "artists," and as such we were supposed to somehow instinctively know how to draw. We were taught a few techniques and then left to struggle. It was believed that art could not to be taught—it was a natural talent that people were born with. Because I found drawing hard, I figured I lacked drawing talent and that was that.

I decided to focus my efforts on watercolor painting. I was an impatient artist and watercolors were fast. I could draw well enough to get a few basic shapes into the painting and the rest was all technique.

Starting in 1981, I worked part time as a forensic artist for the North Idaho Regional Crime Lab in Coeur d'Alene, Idaho. I'd like to boast that I was hired because I had brilliant drawing ability like Leonardo da Vinci, crime-solving skills like Sherlock Holmes and courtroom experience like F. Lee Bailey... Well, not exactly. I was hired because my dad was the director of the crime lab, and I was the only artist he knew.

My original duties were to sketch crime scenes and prepare trial exhibits for the physical evidence presented in court. One day a flyer for upcoming composite drawing classes at the FBI Academy came across Dad's desk. Dad always thought FBI training was interesting, so in 1985 I started a two-week class in composite sketches at the FBI Academy in Quantico, Virginia. I was clueless as to exactly what this meant. I would be the first composite artist from Idaho.

I learned that a composite drawing usually is a face created by combining separate facial features that the victim or witness of a crime selects from a book of faces. The composite is a form of visual communication between law enforcement agencies and the witness. It's used to identify an unknown suspect.

Upon returning to Idaho, I traveled about the state and eastern Washington sketching "the bad guys." I had some successful identifications, and my drawings improved. In 1986 a detective approached me and asked if I would teach him how to draw composites.

I thought a lot about his request for the next year. Could I teach composite sketching? If I taught, would I still be able to sketch, or would I find myself out of work? I finally decided that I would be more effective in this field if I taught. After all, I was doing thirty to forty drawings a year for various agencies. If I taught ten students to draw, three hundred to four hundred drawings a year would be produced and more suspects would be identified.

Now I had to decide what to teach. A composite artist must do two things well: draw and interview. For the next year I attended various courses and training sessions in interviewing, I read every article and book on the subject and interviewed officers. I was then ready to teach the interview section. As for the drawing part, fortunately the man I met at the FBI Academy, a brilliant and gifted artist, became my husband and drawing mentor. With his help, my drawing skills improved.

At this point I made a decision about my composite drawing classes that had never been done before. I decided to teach composite drawing and not assume that my students could draw.

Having chosen this route, I set my course of action. The classes were to be one week long, for a total of forty hours. In that time, I only had two and a half days to teach every aspect of the human face. I needed a half day for the interview and a day for the students to practice. I reserved Friday for special needs.

Many of my law enforcement students were already gifted artists, and many had great doodling skills. But some couldn't draw blood with a knife. They all learned to draw equally well.

I now have three binders overflowing with the success of this program. My husband and I travel across the country teaching composite and forensic art to law enforcement agencies ranging from the FBI to two-person departments. Our students' sketches have identified such perpetrators as child killers, rapists, abductors, murderers, bank robbers, drug dealers and the largest serial arsonist in U.S. history.

My original reference materials were "draw the face" type books. I soon realized that a more detailed book, such as this one, was a necessity. The level of facial information I was teaching to my students didn't exist in any drawing book. Composite artists cannot draw what they feel or take artistic license like regular artists. Their drawings come not from their creative dreams but from a witness's nightmares.

I had a great advantage. No other author of portrait books had the same access to faces that I did—boxes filled with thousands of mug shots. Over the years, I placed the mug shots on an opaque projector and measured thousands of faces for the information in this book. I also had to figure out how to teach people to draw well in an extremely short time. I studied my students' drawings in class and the composites they sent me after successful identifications. I listened to their questions and my answers.

Through teaching adult education and artist-in-residence programs, I expanded the classes to civilians and children. Their work also is included here.

I hope you will enjoy learning about faces in this book. God bless you on your artistic journey.

Composite faces are made up of a variety of features chosen by victims or witnesses from mug shots or from the FBI's book of facial features. These drawings act as a tool to help identify unknown suspects. I created this fictional composite from at least ten faces.

COMPOSITE DRAWING
12" × 9" (30cm × 23cm)

Looking the Part:
Materials and Supplies

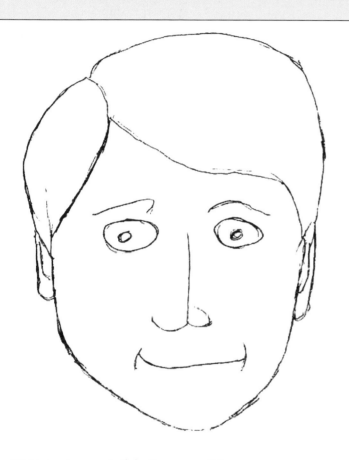

These drawings are both by the same artist, John Hinds, one of my students. Look what a difference just one week of instruction made in his technique!

SELF-PORTRAIT
John Hinds
12" × 9" (30cm × 23cm)

My composite drawing classes are quite different from most drawing classes. Unlike a college class or one taught through an arts organization, these classes are completed quickly and with the maximum amount of information crammed into five days. The participants have only two and a half days to learn how to draw *any* face. Most students are very nervous and intimidated by the prospect of learning how to draw anything in two days. Students also feel pressure because their departments have paid a fair amount of money for this class, and there are rape victims and homicide cases often depending on how well they do. If that isn't enough, my typical students are armed police officers. It's important that I clearly explain the first rule of art (see below) to establish the correct atmosphere for learning.

The first rule of art

It's not how well you draw; it's how cool your drawing stuff is.

Basic materials

Ha! So you thought you knew art. You simply gotta have the right toys to play with the art guys. Most of the materials and supplies I mention are available in art stores, drafting supply stores and the drafting/arts section of many office supply stores.

 TIP *Keep your pencils sharp. Dull pencils are not only difficult to use, they are not cool (see The First Rule of Art on the previous page).*

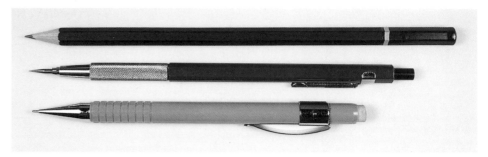

Make a point

I prefer using a lead holder because I can get a very sharp point on it using a lead pointer (a special pencil sharpener for this type of pencil). Regular drawing pencils take too long for me to sharpen, not to mention that you need to sharpen them with a craft knife or a razor blade. Sharp razor blades cut things close to me, like fingers, so I avoid them. If you're using a lead holder (middle pencil), be sure it is just that—there are also mechanical pencils (bottom pencil), which seem like lead holders, but the main difference is that they hold a very thin lead that cannot be sharpened.

Get the lead out

Pencils come in a variety of lead grades, although the term "lead" is incorrect. You are actually using graphite. The yellow school pencil everyone has used is usually an HB lead. If you lined up the pencils with the HB in the middle, the numbers would get larger as they moved out from the center. An easy way to remember this is to think of *H* as "Hard"—the farther out from HB, the harder the lead. Hard = a lighter line. Going the other way, the *B* might stand for "Bold," and the leads would become progressively darker. Choose leads depending on your hand pressure, the paper, personal taste and your budget. I generally use a variety including 2H, HB, 2B and 6B.

The secret life of pink erasers

Very few people have spent enough quality time with their erasers. Oh, sure, you buy a big, fat pink eraser and think you're on top. The truth is, pink erasers don't like your paper. They are fine for those big, industrial-strength boo-boos, but they'll tear up your paper if you use them too much. Get one, but keep it for emergencies.

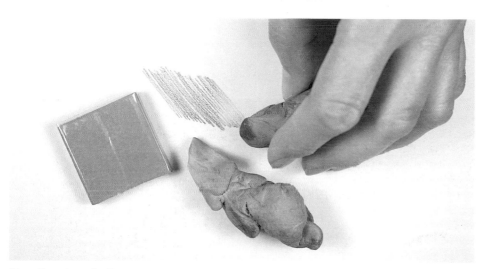

More than kneads the eye

Kneaded rubber erasers start out in neat and dignified-looking squares, but they soon resemble wads of chewing gum under your desk. Kneaded erasers are very useful for a variety of reasons. They are "clean erasers," that is, they will not make any eraser mess on your paper and they clean themselves when you pull them out and re-form them into another shape. Kneaded erasers have two important qualities: They can be pulled into a variety of shapes to erase itsy-bitsy areas, and they can be pushed straight down on your drawing to lighten a tone without messing up a particularly brilliant drawing.

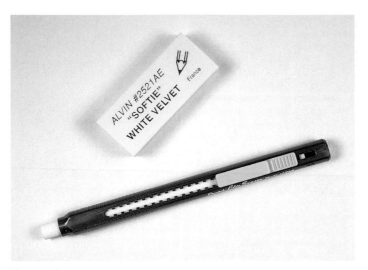

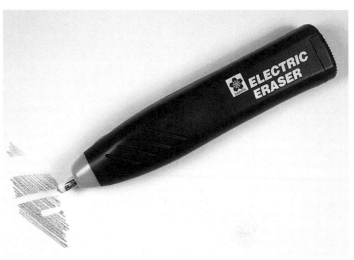

The gentle eraser

Next to the kneaded eraser, the best all-around eraser is the white plastic eraser. It erases well, is gentle on your paper and comes in a "click" pen—always a fashion statement.

Only the best

OK, everybody always laughs at my portable electric eraser. They think I'm a slave to the latest trends, fancy cars and color weaves. All this turns to envy when they see how well this little puppy erases. Nothing is greater than an electric eraser. It is small, lightweight and can be held like a pencil. It quickly and cleanly re-establishes your edges. Not only does it erase better than any other eraser ever invented, but by using it you are immediately branded as a real "artist."

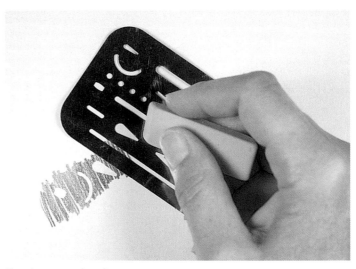

Flossing your drawing

Erasing shields are the dental floss of drawing—inexpensive and indispensable tools that allow you to clean hard-to-reach areas. I have a mondo version that allows me to shade outside the lines and erase the overflow up to the very edge without affecting my drawing.

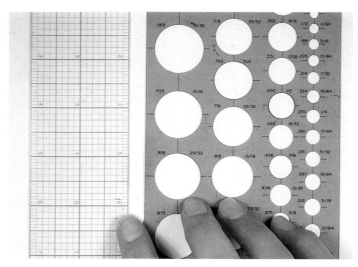

Rulers and templates

Ever say to yourself, "I can't even draw a straight line"? Neither can I. Nor can I draw a perfect circle. This is where a plastic C-Thru ruler—my personal favorite brand name, but you can use whatever ruler works best for you—and a circle template come in handy. The ruler has a very useful grid on it and a centering row of numbers. You can find a similar ruler at the fabric store. The circle template is indispensable in making your irises perfect circles.

Blending tools

Paper stumps and tortillions blend pencil strokes into smooth, finished drawings. A paper stump is a compressed wad of paper that you use on its side to smooth and shade the pencil lead. The tortillion is rolled paper that you use on the tip for tiny areas that need smudging. Using the tortillion on its side will result in corduroy skin.

A few words on paper

On the first day of any of my classes, both watercolor and drawing, I always go over materials and supplies—even if my students are experienced artists. It's because there is a method to my madness and a reason I use the tools I use. I once had a woman in class who ignored my paper suggestion. She bought the cheap, worthless stuff that is passed off to clueless, emerging artists. She just couldn't figure out why her art looked so bad. The paper you use will make a difference in your art. For drawing I use plate—or smooth-finish bristol board. Tracing paper is also important. A cheap pad of tracing paper has thousands of uses (OK, so some cheap materials do work well).

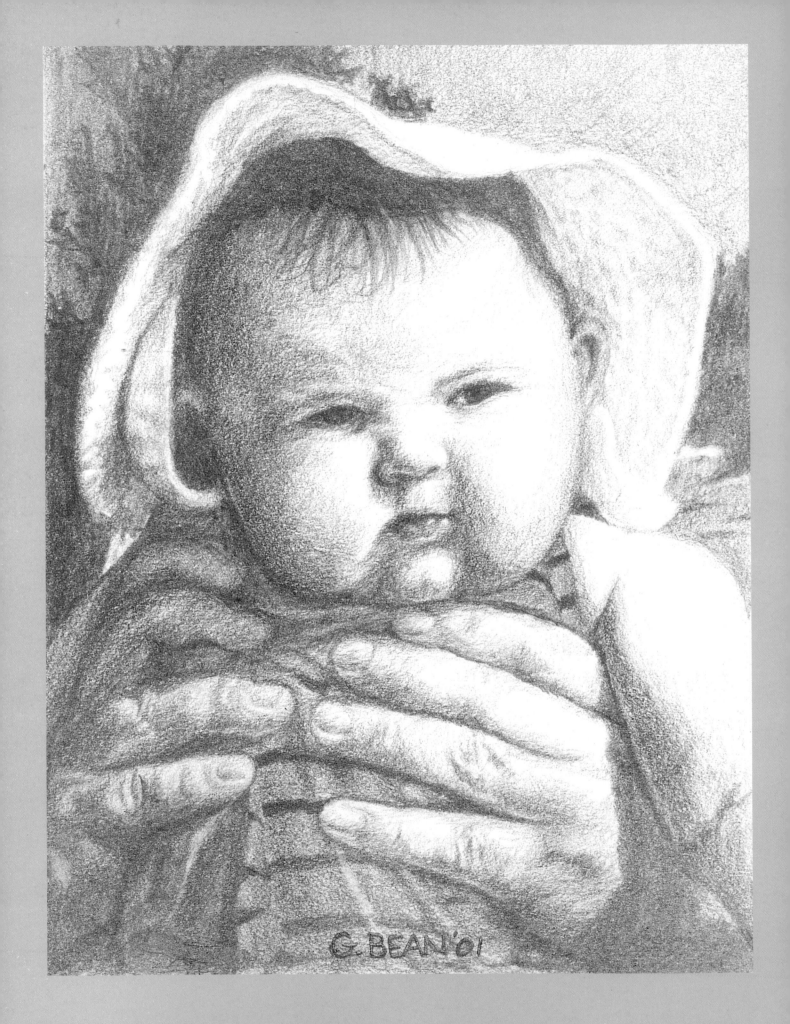

G. BEAN '01

The Problem

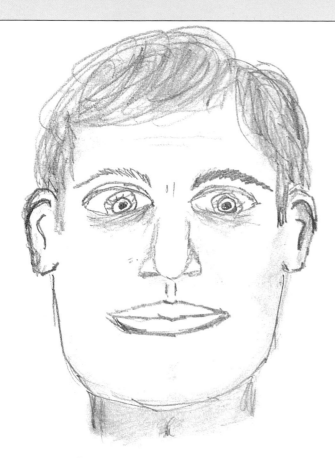

Here are two before-and-after drawings by another of my students, Greg Bean.

SUNBATHING BABY HANNAH IN HER DADDY'S HANDS
Greg Bean
12" × 9" (30cm × 23cm)

Growing up I was very influenced by my parents. Both my dad and mom were teachers. To this day, their students who had a class with Mom or Dad thirty to forty years ago, will come up to me and tell me how much they learned from and liked my folks. Dad, especially, was considered a tough teacher—he taught chemistry, physics, math and law enforcement. Mom and Dad shared their teaching secret with me, and it has been my rule of thumb for all of my teaching experience: If a student doesn't learn, it's because you are failing as a teacher.

Over the years, I have kept that firmly in mind. If someone does not draw well in my class, it's my fault. I haven't found the way to communicate the necessary information to the person in a way that makes sense and works for him or her. This is why I explain why, how and what it takes to draw. This is why I have so many approaches to drawing. And this is why I measure, listen, watch, talk, review and continually improve the fine art of learning to draw.

Most importantly, I truly care that you learn to draw well. I hold back no secrets. I present all the information in many different ways, because one way might make something clearer to you. In my classes, I never doubt that my students will not learn, because I will not fail them as a teacher.

Why is drawing so hard?

Before you continue in this book, I strongly advise you to complete a pre-instructional drawing. This is a yardstick by which you will see improvement in your skill level of drawing. As your drawing skills improve, your knowledge of drawing leaps ahead of your actual ability to draw. It is easy to become frustrated by your apparent lack of progress. Yet, in fact, your abilities have improved tremendously. Tracking progress by using pre-instructional drawings will help you see clearly what you have learned and will provide a great deal of amusement when you go back and see your original efforts.

Most people, including many artists, have trouble drawing faces. Why is this? It's because drawing is "seeing." Most people draw what they think faces look like, and the end result may not match the image in their minds. So, first I will help you discover why you have trouble seeing. Then, I will show you how artists see and what tools they use to help them translate their mental images into drawings. Finally, you will learn what to see, or how to render the facial features themselves.

Drawing things the way they really are is not a gift given to artists. You may think drawing has something to do with hand-eye coordination, but it really has everything to do with how the mind works. Your mind takes information from the surrounding environment and places it into patterns—symbols representing an idea, concept or information. This organization into understandable patterns is called perception.

There are three important points you should know about perceptions:

- Perceptions are filters through which you see the world.
- Perceptions are powerful.
- Perceptions do not change.

Perceptions are filters

Perceptions are filters through which you see the world. Your mind records and processes information through the five senses. This information, however, is not recorded like a movie camera. Instead, it's translated into an understandable form for future use.

When you first started school, you learned that the shape shown below was the letter *a*. Whenever you saw that shape, you knew what it meant and the sound it made. It was not necessary to relearn that shape every time you read it in a word. It could look like any of the shapes you see below, and you would still know it was the letter *a* and that it represented a sound. In fact, you didn't even think about the shape of the letter *a* after you learned it. Your mind provided the information for you. You no longer really "saw" or had to think about the letter *a*.

Simply stated, this is how the mind processes information. It memorizes what a shape represents, like how the letter *a* represents a sound, and every time you need to write that sound, your mind

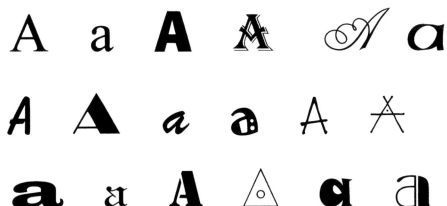

No matter how you look at it, you know these are all examples of the letter *a*. Thanks to your mind's ability to memorize patterns, you don't have to relearn what this symbol means every time you see it. These patterns also allow you to quickly recall the sound associated with the letter.

provides this shape: *a*. It's important that your mind does this. Imagine what would happen if every time you came to this letter you had to relearn what it meant!

Thus, the first point you need to realize is that the untrained mind draws pictures from memorized patterns. When you draw a face, your mind provides the memorized shapes representing the eyes, nose and mouth, not the real shape of the facial features. You draw what you perceive to be real, not what is real.

Where did your mind get these shapes? Let's look at some pre-instructional drawings and figure out the source of the shapes.

Memorized facial patterns
These drawings are typical pre-instructional drawings by nonartists. They have some rather standard patterns representing the face.

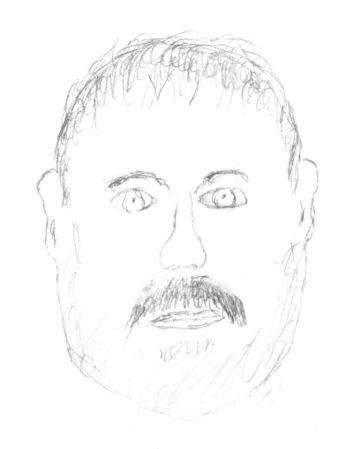

A typical pre-instructional facial drawing

Eye patterns
These eyes are part of pattern memorization for the average person.

Nose patterns
Noses offer a variety of shapes such as these.

Mouth patterns
Mouths might have a "have a nice day" smile or an upper and a lower pair of lips.

TIP *Your drawings are based on perceptions formed from pattern recognition and memorization.*

Perceptions are powerful

Perceptional filters will prevent you from seeing information that is clearly before you. These filters may prevent you from drawing something accurately, even if it is right in front of you.

Perceptions do not change

Perceptions do not change unless a significant event occurs. Without instruction, you will continue to see and do things according to your understanding of them. My greatest wish is that this book will constitute a significant event and that as a result, your perceptions on drawing faces will change.

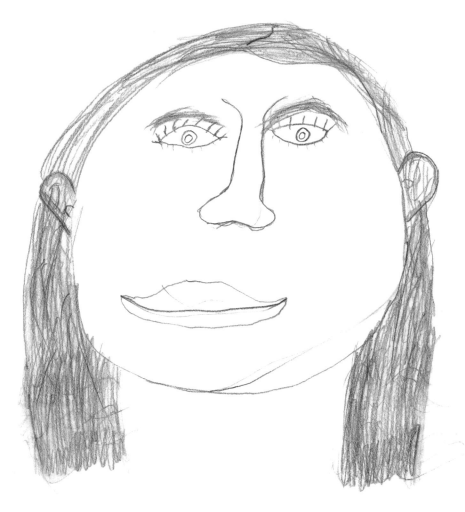

Pre-instructional drawing

This drawing is by Taylor Perkins. She was looking at her face when she drew this sketch—every detail was in front of her—yet the information was meaningless. Notice, for example, that her eyes are placed near the top of her head. Had she been able to see her face without filters, she would have noticed that her eyes are in the middle of her face.

TIP *To break patterns, you must first recognize that you have them.*

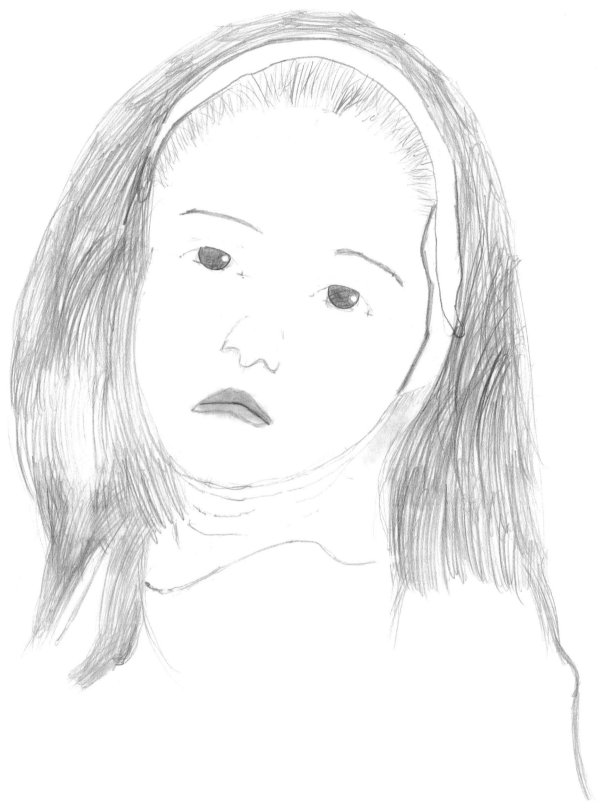

After instruction
The photograph that Taylor was looking at provided all the information she needed to create a realistic self-portrait, as shown by this drawing she completed after a bit of instruction. The power of perceptional filters and the persistent nature of the mind to continually process information into patterns is the challenge to drawing well—but you can learn!

TAYLOR PERKINS, AGE 7, SELF-PORTRAIT
14" × 11" (36cm × 28cm)
Collection of the Perkins Family

Natural artists

People I call "natural artists" are those who, for some reason, have been able to draw accurately without knowing exactly why or how they are able to do this. Generally speaking, this ability seems to be spotty. They can draw some things well and other subjects not so well. Such comments as, "I can draw animals and landscapes great, but I can't draw people," are very common.

These artists have learned some drawing techniques naturally, but have yet to learn how to change all their perceptions about the world around them.

Natural artists who have undergone some form of art training are usually able to draw most everything well. However, whether you are a trained artist or are a natural artist, your mind still places all incoming information into a pattern of perception. After a short time, you stop seeing what you are rendering and draw a pattern. It's a more sophisticated pattern, a well-drawn pattern, but a pattern nevertheless.

Without having the phenomenon of pattern-memorization explained, you might have used some technique to "review" the completed drawing. You might have to take a break from your drawing, turn your drawing to a mirror or place it up on an easel. Now you can see why this is necessary. It helps break the patterns and to "see" your work of art with fresh eyes. This is called checking for accuracy, and it's a drawing tool that natural artists use.

What are you looking at?

The best way to begin your artistic journey is to learn how to look at things. Drawing is seeing.

I have taught many art workshops. I remember in particular this sweet woman and her first oil painting. It was a half-completed bowl of daisies on a table. The daisies were all facing toward the viewer, and every one was identical. There wasn't a single small or big daisy reaching for the sky. I asked the eager artist if I could see the reference photo she used for this painting. I needed to point out the variety of images, shapes and colors. She said there wasn't a reference photo, the image came from her mind.

Your mind pretty much has a pattern for everything. Never try to imagine something in your early art career—look at it. Then you will be able to draw it accurately. Always look at it.

OK, so I'm looking at it

I have told you so far that drawing is seeing, that your brain uses patterns to record the information and that you rely on those patterns to draw. Furthermore, you know that you need to break those patterns of perception by having something in front of you to draw. OK, so you're looking at it. Now, a miracle happens and you can draw, right?

Ah, not quite. Knowing what the problem is doesn't solve the problem. You've just completed step one: Why you can't draw. Now I will go into step two: What are you looking at?

There is simply too much information for your tired, pattern-hungry brain to go through without some kind of manual or guideline. You need to learn how to sift through all the information to make sense of it and be able to use it. Like a "some assembly required" kit, the parts are all there, but it takes a manual to know what you are looking at and where it goes. There are four basic components to assembling a kit—and to drawing:

- Site
- Shape
- Shade
- Accuracy

You need to know what the parts look like (shape), where they go (site), what the finished product looks like (how to make it look real—shade) and how to fix the wobbly parts (accuracy).

Site

It's easy to say that artists need to learn how to see things the way they really are, not the way they think or perceive them to be. Most books say that. Not only do most people not see the reality of the world around them, they also don't place the objects in the correct location. Sure, they know that the eyes are above the nose and mouth and that somewhere beyond that is hair. But there's more to it than that.

Measuring and determining the correct location and size of different items is called proportion. When something is in proportion, it's correct in scale to the other items in the picture. It's easy to look at a picture and know when something is out of proportion, but how do you draw something in proportion? Learning how to correctly proportion images in a picture through the use of artistic tools will be covered in chapter three.

Natural artist?

You weren't born with the innate ability to know how long a meter is or how many cups are in a gallon. You learned which of the various measuring tools to use for each application. Drawing also has measuring tools. Look at the two examples shown here, both drawn by the same student. Notice the relative size and location of the facial features in the pre-instructional drawing. Even if the features were correctly drawn, they are still in the wrong place. Note the difference in the later drawing.

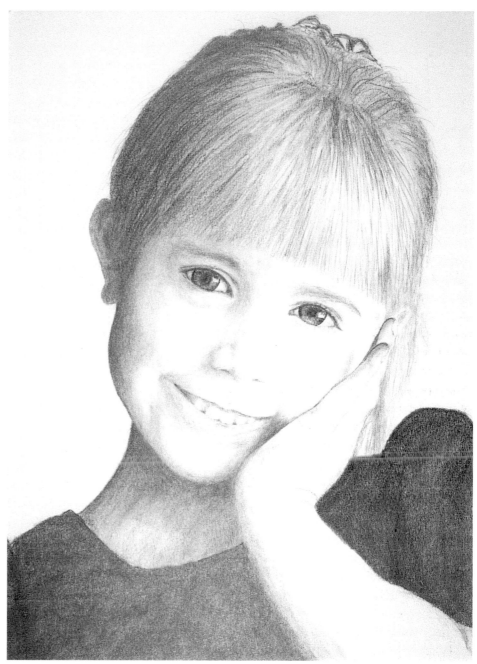

HEATHER
14" × 11" (36cm × 28cm)

Shape

Basic shapes are not easy to identify when drawing. You need to know what to look for. Shape Identification 101 started in kindergarten, and ceased shortly thereafter. Most people are not formally trained to see shapes for drawing purposes. You have to learn this skill. Once you've determined the correct size and location of an object, you can then concentrate on the shapes of the object you wish to draw.

An artist automatically filters out all but the barest shapes to begin with. This is not talent, it's training. We are training our minds to see the subtle shapes in the visual world around us.

Shade

The next step in the drawing process is shading. Shading makes something look real (as shown in the example to the right). Most people have never learned, however, to evaluate and see shading. Yes, you can see that black jeans are darker than blue jeans. But shading requires more special knowledge and tools. Learning to shade also involves learning more about your mind and the power of your perceptions.

Accuracy

Finally, you need to be able to learn how to overcome your brain's desire to put the world back into patterns. How can you keep checking to see if you are doing well? In the back of most do-it-yourself kits is a problem-solving section. You need a similar chapter in your drawing routine. Ask, "What is wrong with the shape of this face?" This is checking the accuracy of the image.

Simplification

The visible world around you is rich in information—actually, there is too much information for any emerging artist to understand. It first needs to be simplified for you to see just exactly what it is that you are looking at. This is why it's easy for people (especially children) to draw cartoon characters so well. The shapes are simplified, outlined in black and easy to see. Most people can draw these shapes with little or no instruction, other than what they've learned about drawing letters.

Seeing without outlines

Many children show great interest and talent in drawing cartoons. Often when they are introduced to regular drawing, they will lose interest or give up. The problem is not their lack of talent or even interest; it's in how they are taught to see the same simple shapes in the photograph (or world). Drawing the world around you involves using the same basic shapes. They're just not outlined in black ink anymore.

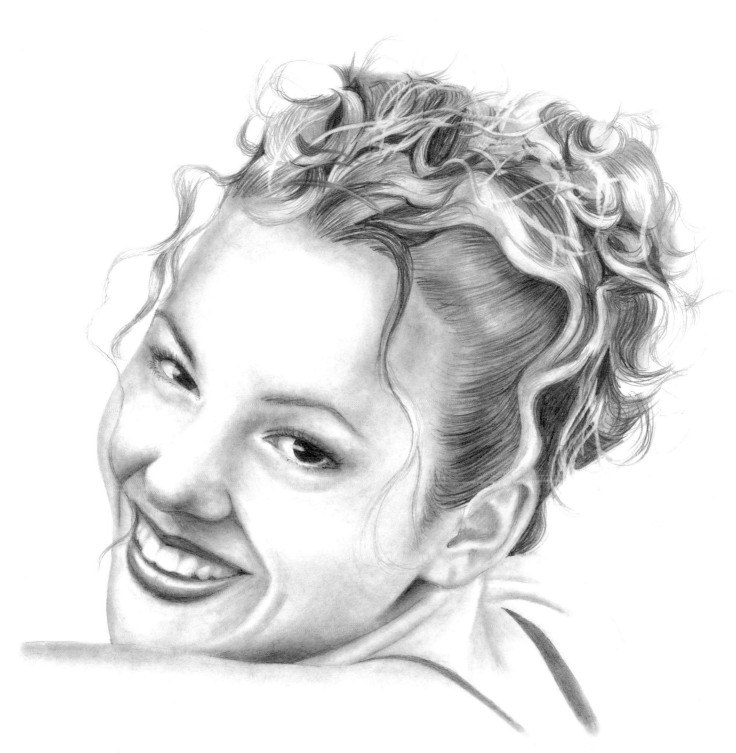

Look at the girl's hair and face. Without the appropriate shading her features would have looked unrealistic and incomplete. Learning how to shade properly can save your drawing from the recycle bin.

PHOTO BY KELLY DULANTY
12" × 9" (30cm × 23cm)

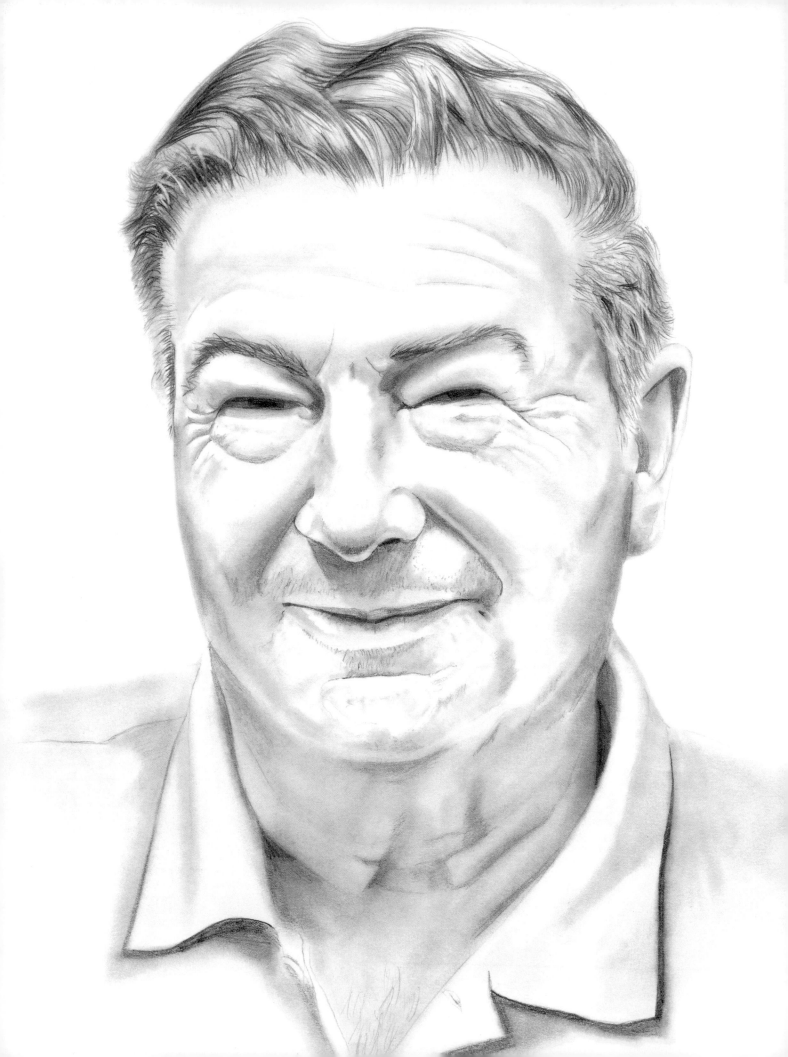

Site

DON PARKS
12" × 9" (30cm × 23cm)

When artists first start to draw, they usually begin by sketching the overall images—the location and placement of where things will go. If they intend to make a realistic picture, they'll need to make sure everything fits and is the correct size. Once everything is scaled, they'll start refining the details. I will teach you to approach drawing the face in the same way. We will start with the locations, or sites, of the facial features. Then I will instruct you how to render the correct proportions of the average adult face.

Learning proportions and scaling a picture is not a skill people are born with. I'll teach you how to figure out the proportions using tools to help you. You'll learn three primary tools in this chapter: measuring, flattening and optical indexing. In the past, you've probably heard about vanishing points, eye levels, two-point perspective, horizon line and parallel perspective. Scrub all that. You can draw anything in perspective using only measuring, optical indexing and flattening.

Measuring

Any object in front of you is measurable. Most people have been taught to measure an object by comparing it to something they know. Traditionally, you may compare something to a specific measurement, such as a ruler. There is an expression "bigger than a bread box"—though most young people today have never seen a bread box. This is a comparison. Everything in front of you can be compared. An object is either the same size as, larger than or smaller than something else.

Bigger than a bread box
Using a map as an example, you check the distance from one point to the next by comparing it to the map scale. You don't use the scale to measure another map or the length of a baseball field—only the contents of this particular map.

You can measure a variety of objects using other forms of measurement, such as a gallon or a meterstick Artists also measure objects. The difference is that they measure an object by comparing it to itself.

All about baselines
A baseline is a comparison system. For example, when compared in a range of Chihuahuas to Great Danes, a "big" dog is a German shepherd. A German shepherd, however, is not all that big when compared to an elephant. Size is relative to what is being compared. When you use this system in art, you compare the baseline in the image in front of you to something else in the same image. For example, you may wish to compare an object's length to its width. Because you'll be drawing this object, you also have a straight line that you can use as a baseline in your drawing.

Establishing baselines in photographs
The easiest way to measure objects with a baseline is to use photographs. Photos don't move, are already in two dimensions and are easy to refer to. To do this simple exercise, you will need a pencil, an eraser, a sketch pad, a scrap of paper and a large, easy-to-see photograph.

Proportions

Proportions are like maps—they provide an overall view of where things are and how they fit into the whole picture. Most people have a pretty good idea where the facial features are located. The eyes are above the nose and the nose is above the mouth and so forth. The first drawing concept is on how to locate various items we wish to draw with more exactness.

Some books written about faces are not always correct on the placement of the facial features. They may generalize or use some kind of Greek idealized face with a long, thin nose. Once again, it's important to look at something to draw as you continue this process. It's hard to measure, line up and view images that you've created in your mind.

Proportions are a comparison, a relationship between objects dealing with size, volume or degree. You may be able to draw the greatest eyes in the world, but if they are in the wrong place, the drawing will be off. Proportion is the relationship of different elements in a work of art.

Establishing baselines in photographs

① Choose a baseline

Select an object in the photograph that is measurable with a straight line, such as the width of the eye from side to side. Your baseline should be easy to see and a fairly short line (a small area like the eye). Take a scrap of paper and measure that width.

② Transfer the baseline width to your paper

Place the same length of line on your paper. The line you have marked on your paper is your baseline. With this one single, simple line, you can proportion and render every other facial feature.

③ Compare and measure the other features

Compare the proportion of one feature to the baseline. Using the same scrap of paper, you can now measure every other part of the face by comparing it to the width of the eye.

④ Place the correct measurements

Mark each measurement on your paper.

How to establish a baseline on a three-dimensional subject

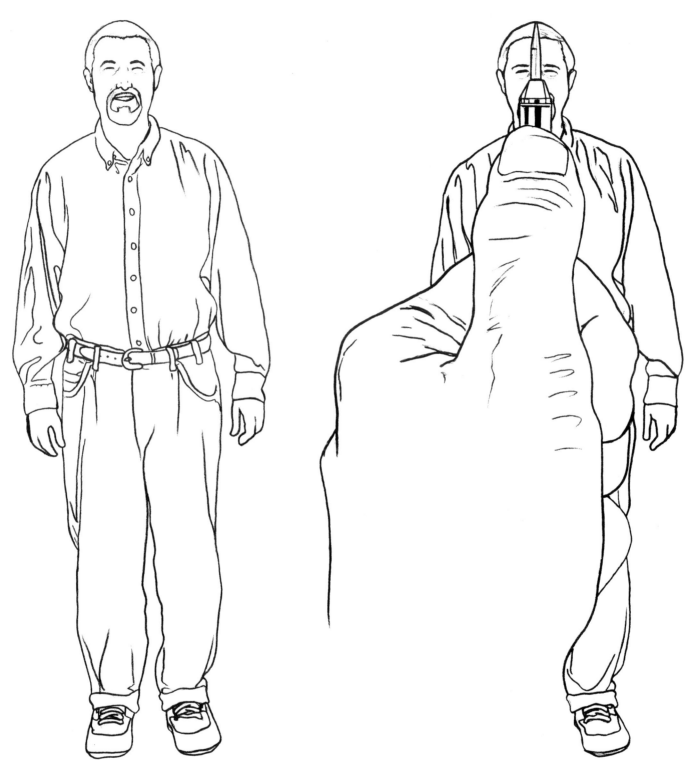

1 **Select the baseline on the subject**

Select a portion of the face or body to use as your baseline. The baseline should be a fairly small horizontal or vertical line. Remember that a baseline is something you will compare everything else to in your drawing.

2 **Measure the baseline**

Extend your arm straight out in front of you, holding the pencil as illustrated here. Close one eye and use the tip of the pencil to mark the start of the head. Use your thumb to mark the end of the head. This measurement is your baseline.

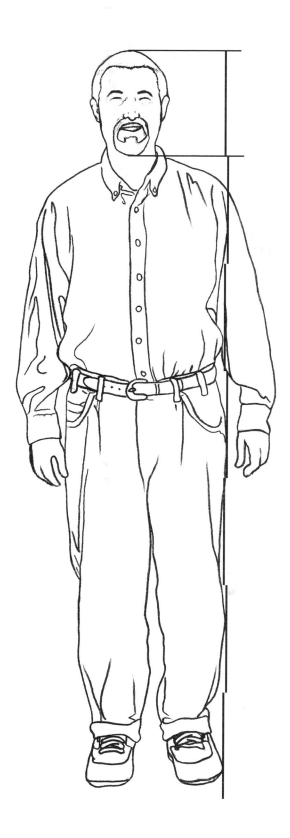

③ Compare the baseline measurement to the figure

Using the measurement of the tip of the pencil to your thumb, compare the figure to establish if something is the same size, larger than or smaller than that measurement. For example, compared to the height of the head, the height of this person's body is six "heads."

Using this system, you can compare the height of the head to all other parts of the body. Whatever measurement you choose to make the head on your paper, you will compare the rest of the body to that starting point.

Anticipated problems

Three important secrets to using a pencil as a measuring device:

1. Hold your pencil as if it were a piece of paper in front of you. In other words, don't angle the pencil away from you. You're trying to draw a three-dimensional object on a two-dimensional piece of paper. You cannot draw into the paper, so hold your pencil flat.

2. Extend your arm fully. If you keep moving your arm to varying lengths, your measuring will be off.

3. Always close the same eye.

OK, so I measured it. Now what?

Let's summarize what you've learned so far. To establish the correct proportions of a three-dimensional world and put it onto your two-dimensional piece of paper, you do the following:

1. Select a baseline from some object in front of you that should be straight, short and horizontal or vertical to you.

2. Use a pencil, pen or other straight object held in front of you at arm's length to record the length of the baseline.

3. Make a mark on your paper to represent that same length.

4. Use the baseline measurement for comparison to other objects in the picture in front of you. Everything should be the same length, longer or shorter than that baseline.

5. Use the drawing baseline to make the same proportions on your paper.

Measuring the face

You can locate the eyes by using the same concept of measuring the head and comparing it to the body. This is an easy exercise for all ages.

Here's the finished drawing that will be the base for the exercise in measurement.

Measure the face to locate features

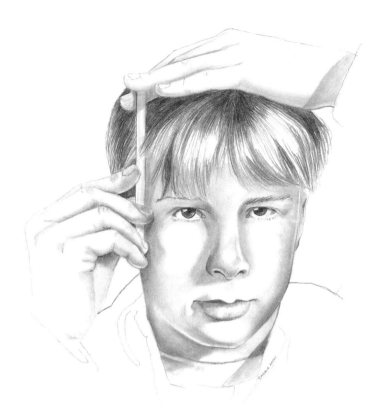

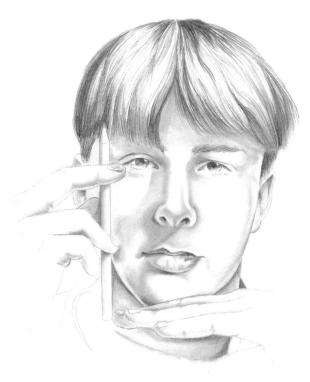

① Measure the location of the eyes

Compare the distance from the top of the head to the eyes. This will be the first and simplest baseline.

Lay one hand flat on top of your head, and take a pencil in your other hand. Hold the pencil tip with your flat hand. The hand holding the pencil should point toward your eyes. Use the pencil to help you measure the distance from the top of your head to your eyes and locate the eyes.

② Compare to the distance between the eyes and chin

Compare the previous distance to the distance from your eyes to your chin. On most people, the distance between the top of the head and the eyes is about the same as the distance between the eyes and the chin.

Enlarge your drawing the easy way

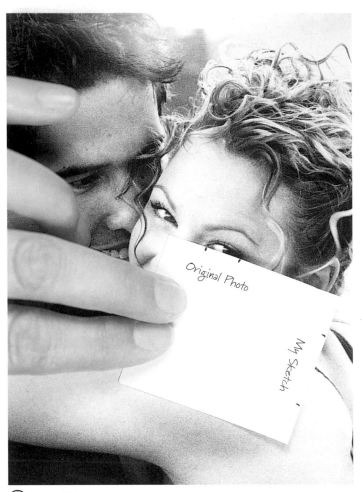

① Scrappy solution

To enlarge a drawing, take a scrap of paper and mark the original measurement on one side and the enlarged measurement on the other. In other words, make the baseline larger.

② Eyeball it

By establishing the eye as the original baseline, you can now compare that measurement to every other feature on the face. Use the original baseline side of the paper every time you measure a feature on the original photo.

My Sketch

Original Photo

③ Reuse or Reverse

You will use the enlarged side of the paper to draw that same feature again and again. You can proportionally enlarge a drawing to any size using this method. Reverse it to make something smaller.

More measuring aids

This site-measuring technique is very useful. Not only can you measure something in front of you and draw it the same size, you also can use the same tool to enlarge or reduce a picture. To draw something the same size, mark the established baseline and one other measurement on your paper.

There are more tools—some of them are pretty expensive—to help you measure. Besides being able to enlarge or reduce the size of a picture, you can also use these tools to help you measure curved shapes. Probably the most useful tool, although expensive, is the proportional divider. This device offers an adjustable way to measure and compare two images. It has a sliding screw that allows you to adjust the width to any two images—your drawing and the image you wish to draw.

Measuring curved shapes

Measuring a curved shape with a straight edge can cause you problems. It is difficult to correctly see and accurately draw curved shapes. How can you measure a curve with your straight-edged measuring tool? The good news is that you use the same tool, you just measure the start and finish of the curve.

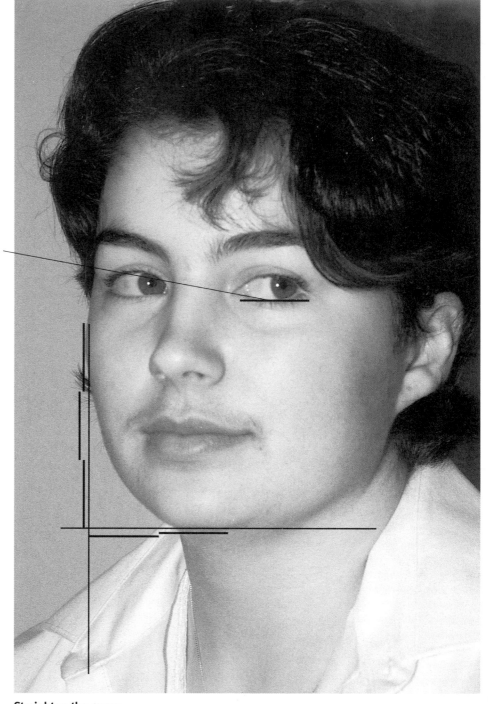

Width of eye

Straighten the curve

You can measure the curve of the cheek in the photograph by using the eye baseline. Draw two lines, one at the start of the curve of the cheek and one at the chin. The horizontal and vertical lines are measurable distances and give you the start and end of the curve. Take the measurement of the eye and compare it to the cheek. Her cheek curves down two and a half eyes and over one-half eyes. Measure how far up and over the curve goes. You have also created a negative space that will be explored in more detail in chapter four.

Flattening and Optical Indexing

Flattening Tool

When you first used your pencil as a measuring device, you extended your arm and closed one eye. Why did I ask you to close one eye? Try it with both eyes open. It doesn't work. It takes both eyes to have depth perception, which you don't want, because you're drawing on a two-dimensional piece of paper. Closing one eye flattens the world around you. Aha! You've just established a drawing technique! To draw a three-dimensional image on a two-dimensional piece of paper, you must close one eye.

Optical Indexing Tool

The next tool to help you find out where the facial features are located is called "optical indexing." That is a fancy way of saying things line up. What features on your face line up? Is it possible to use the location of one facial feature to find out where the others are located? Take a look at the two drawings on this page and the two photos on the next page, and notice how the features line up.

Note: You will soon begin to notice that you will see the same generic male and female faces throughout the book. Using the same face to teach multiple lessons will help you to better see all the parts that make up the whole. Refer back to individual lessons as necessary.

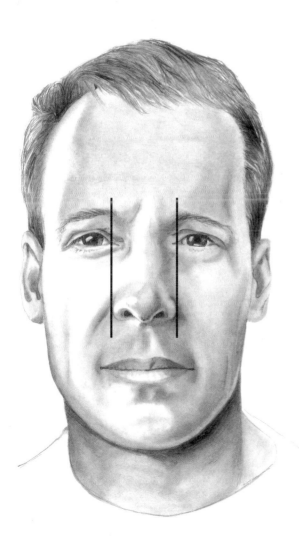

If I make an imaginary line straight down from the eye in this photograph, it will bring me to the outside of the nose. I now know how far down the nose comes to (because I measured it compared to the eye) and how wide the nose is.

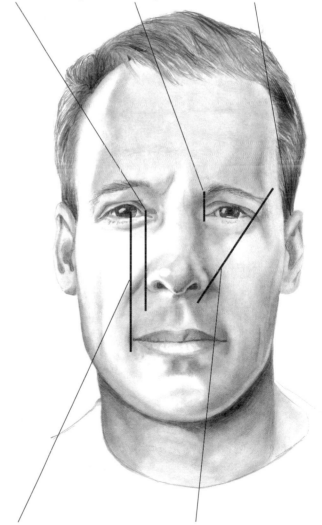

The edges of the male nose line up with the start of the white of the eye.

The eyebrow will often start at the inside corner of the eye.

Ears are roughly as long as the nose, and may run from the eyes/eyebrows to the base of the nose.

The mouth is roughly as wide as the center of the eye.

The eyebrow often ends in line with the nose on the outside of the eye.

Grid/optical indexing

Using a grid is probably one of the old-
est systems artists have used to establish
correct proportions. There are two types
of grids (or optical indexing) you can
use: First, you can draw equally-spaced
horizontal and vertical lines across your
paper. Repeat this pattern on your pho-
to. Now draw the shapes that occur
within each square and locate where the
shapes cross the guidelines. If your grid
is the same size as your photo, you can
draw each shape the same proportion on
your paper. You can also enlarge or
reduce the size of drawings by simply
adjusting the size of the grid on your
paper and proportionally changing the
size of the shapes on your paper. Second-
ly, draw an occasional horizontal and
vertical line or two (or as many as you
need) to orient you on the paper. This
will help you establish location and pro-
portion on your drawing. Either of the
forms of optical indexing are extremely
useful for establishing proportions.

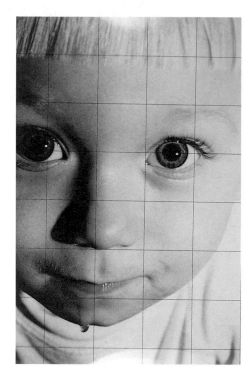 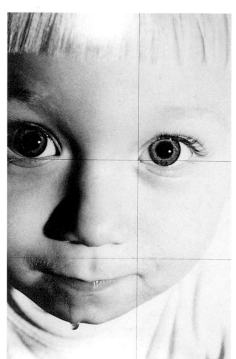

 TIP *You can create a reusable grid
through a variety of methods:*

- *Make a grid on a computer and print it on an
 acetate overhead.*

- *Draw a grid on acetate overhead material.*

- *Draw a grid, run it through a copier and make
 copies on acetate.*

- *Make a grid on a clear insert or folder, and
 slide the photo into the insert.*

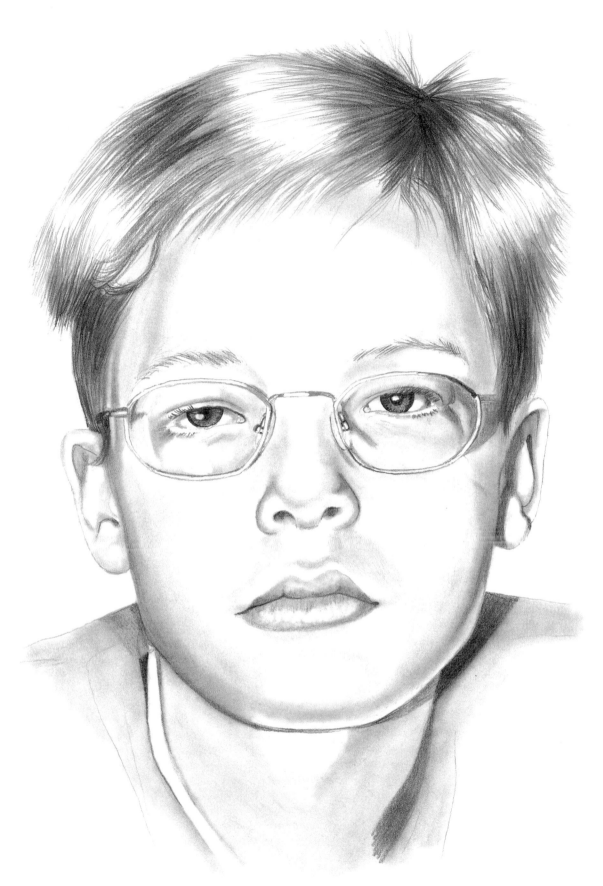

Using the flattening and optical indexing tools, I was able to accurately line up the features of Jeffery's face. The optical indexing tool was especially useful for helping me draw his glasses in proportion to the rest of his face.

GARRETT McDONALD
14" × 11" (36cm × 28cm)

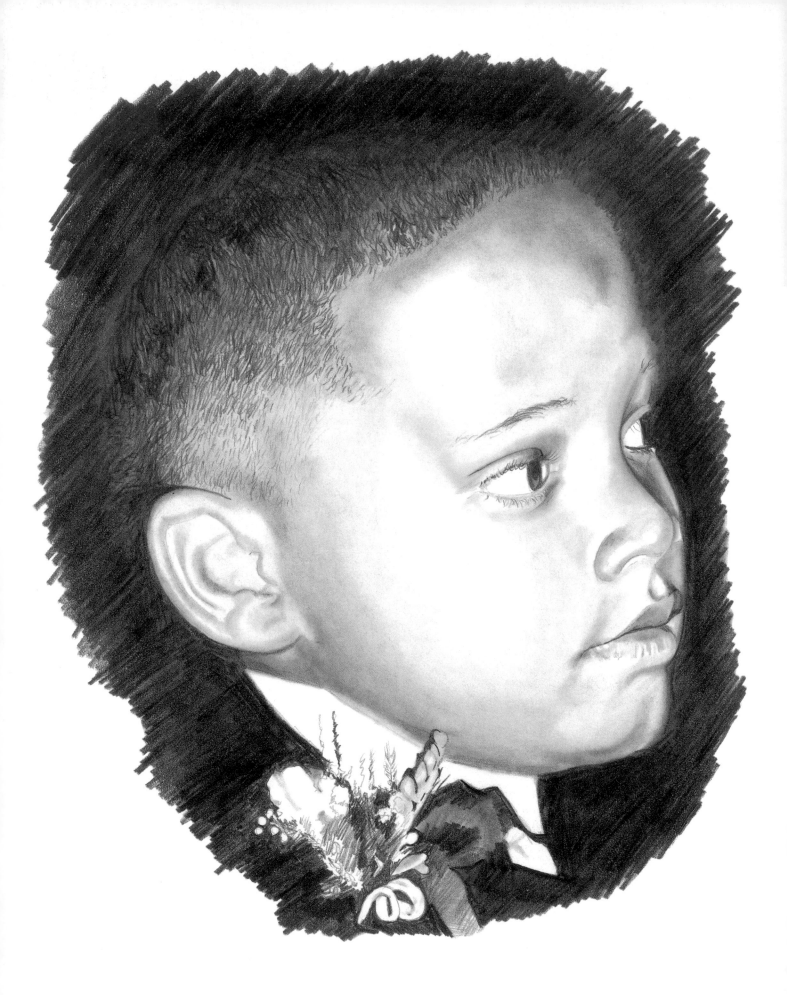

Shape

This drawing is based on an award-winning photograph by B. Kelly Dullanty. It was used with his written permission and the release of the subject in the photograph. That might seem to be a lot of work for just this one drawing, but the alternative is copyright infringement—also known as stealing.

WEDDING
12" × 9" (30cm × 23cm)

You have learned how to map out the locations of the facial features. Now you need to focus on the features themselves—the shapes that make up the face—train your mind how to seek out shapes. In this chapter you'll learn about a series of tools and techniques that artists have learned or developed to help them see better. Artists generally use these tools without even really thinking about them. The more tools or "ways of seeing" you have at your disposal, the easier it is for you to draw accurately.

Even young children can demonstrate this ability to seek out and distinguish shapes. It is this ability that enables them to write letters. Drawing is the same concept, but you must hone this ability to a higher level. This chapter will teach you to discern the subtle shapes in the information-rich visual world.

Train your mind

Learning to recognize shapes in a photograph or image takes training. You need to train your mind what to look for. Once you become aware of something, it's easier to see it. For example, when you are buying a new car you spend time studying the cars on the market. You then go to a dealer and look over the selection. You might fall in lust with a particular model and color. Afterwards, it seems like everybody has the car you were looking at. Did everyone suddenly go out and buy the same car? No, you have simply become aware of the shape and color of that particular car, and you now recognize it among all the other cars on the road. The same thing happens with the shapes in facial features.

Say "cheese"

Because drawing is seeing, you should always have a reference image in front of you. Ninety-eight percent of success comes from having the correct photograph. Your selected photograph should be clear, interesting, big and preferably black and white. If the photograph is small, enlarge it. A computer with a scanner and a reasonable photo program will do the job nicely. Or take the photograph to a copy center and enlarge it to a 8" × 10" (20cm × 25cm) image. Use their best copier to retain all the detail.

Many people start with a studio photograph of a family member. Though theses types of photographs are clear, large and well done, there are a few drawbacks. They're copyrighted by the photographer, so if your drawing turns out well, you can't display it. Second, the lighting is often boring. Flattering, but boring.

Tools of the trade

Okay, so you have found the perfect photograph, now it's time to move on to learning some tools to help you train your mind to recognize shapes. They are:

- Isolate
- Simplify
- Relate
- Measure
- Invert
- Rename
- Incline
- Negative space
- Question
- Compare
- Flatten

Oldies but goodies
Consider the antique photographs sitting in the attic of Great-Grandma Sparks or the wife of your second cousin once removed. An interesting drawing comes from a photograph that is easy to see, clear, large in detail, interestingly lit and preferably black and white. Artists should also own or have a clear copyright use of the photograph. You'll often find these qualities in the antique photos of your family.

Isolate

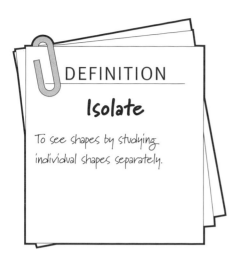

DEFINITION

Isolate

To see shapes by studying individual shapes separately.

Everyone needs practice
See, nobody's perfect. Here's an example of one of my early efforts.

When I was a little girl, I loved horses. I loved to ride horses, and I loved to draw horses. I was very fortunate because I lived on a 680-acre ranch where we could have lots of horses. Like the drawing on the right, my first efforts at drawing a horse were typical of a young child. I knew the horse didn't look like my drawing, especially the hooves. I could see horses' hooves. I studied them. I looked at photographs, and I traced the shape of the hoof with my finger. I *isolated* the hoof and looked at it separately from the rest of the horse, as shown in the drawing on the right. The first artistic technique I used was to isolate the shape. Look at the works of any artist, and you will find sketches of eyes, hands and parts of the face. These artists are isolating each of the different components of the whole of the art that they will be doing.

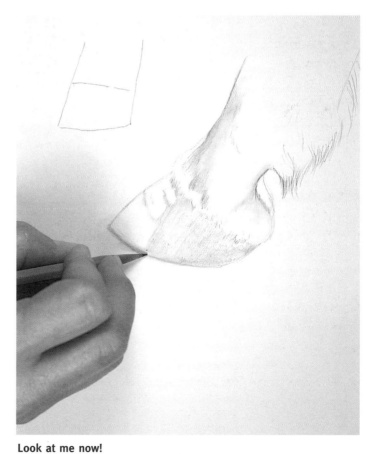

Look at me now!
Isolating features can help you better see the individual shapes that make up the entire drawing. Once I learned this tool, I was better able to accurately draw a horse.

Simplify and Relate

DEFINITION
Simplify

A tool for learning to see shapes by seeking the simplest expression of that shape in the form of a straight or curving line.

DEFINITION
Relate

A tool for learning to see shapes by using one shape to help see a second shape.

Pupil secrets

You might be wondering how big to make the pupil of the eye. The answer is: It depends. The pupil expands and contracts to light. Studies have shown that it also expands and contracts as a reaction to seeing something likable or unlikable. Most artists unconsciously record this piece of information. Therefore, an eye with a small pupil is less likeable than an eye with a larger pupil. If you want people to like your drawing (or in other words, get paid for your portrait), make the pupil large. If you are drawing a bad-guy composite of a cold-blooded killer, make those pupils pinpoint—you'll naturally dislike the guy.

In chapter two, I mentioned that children find drawing cartoon and comic strip characters easy. This is because the drawings are outlined with black ink. The simple shapes—curves and lines—are easy to see. A photograph, or real life, doesn't have the same black outlines to show the artist what to look for. To see the subtlety of the shapes takes training.

In linear drawing, there are only two basic shapes: a straight line or a curved line. The lines go up, down, right, left, but they are either straight or curved. When artists look at the face, they don't try to find eyes or lips, they seek the simplest linear shapes. Seeking the simple shapes removes your memorized, incorrect perception of what constitutes an eye and allows you to focus on the actual reality of an eye. Artists seek the simplest expression of shape as a foundation for building the face. They look for the simple curve, line, circle or shape, rather than an eye, nose or lips.

The dictionary defines "relate" as bringing into logical or natural association, to have reference. The face has a unique shape that helps artists relate other information. The iris, the colored part of the eye, is a perfect circle. The pupil, the black center of the iris, is also a perfect circle and is in the center of the iris. The average adult iris does not vary much from face to face. You can use this information to help you see and draw better.

Look at the correctly drawn eye on the next page. Then, follow the steps to learn how to draw a correctly proportioned iris.

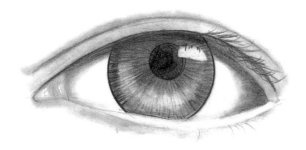

Bad drawing, bad, bad! Now sit...
Using the relate tool, place the pupil in the center of the iris before drawing the lid and other eye parts. You'll resolve the problem of off-centered pupils and the resulting comments like, "I don't know, Marge, there's something wrong with this picture."

Draw a correctly proportioned eye using your template

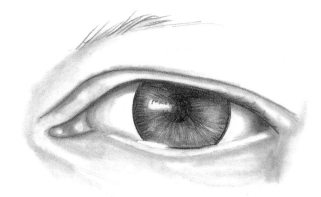

A correctly proportioned eye.

① Relating shapes

There is an association between the various parts of the eye that you can base on the circle of the iris. Using a circle template, draw a circle.

② X marks the spot

Using the top and bottom sides of the circle in the template, connect the lines to the center of that circle.

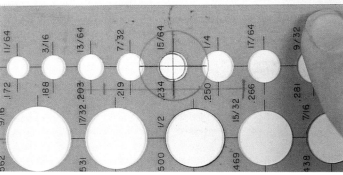

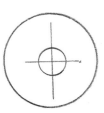

③ Circles within circles

Center the pupil of the eye in the middle of the iris. Check that you are using the correct circle size on the template; it should fit nicely around the center of the lines.

Measure

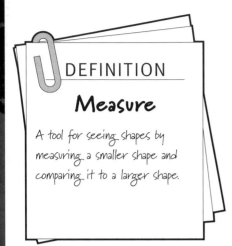

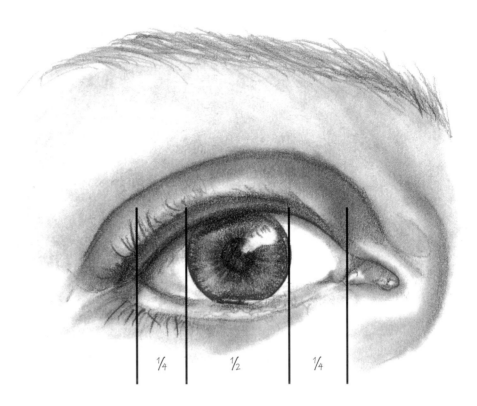

¼ ½ ¼

In the last chapter, you learned that you can measure anything in front of you. This method helps locate the facial features, which then can be measured. Once a single shape is in place, you can use that shape to locate and determine other locations and shapes. Remember that there is one shape that occurs in every average face: It's the perfect circle of the iris.

Go figure...

Measure it for yourself. Knowing that you can correctly measure an eye on a photograph means you should never draw an incorrect eye. It's truly as plain as the nose on your face.

You can use the width of the eye to measure the height of the eyebrow, the length of the nose and any other measurement you might need to check.

Just as you established a baseline within the site tools section, you can select and use a baseline in the shape tools.

Eyeballing a measurement

You can use the width of the iris to determine how wide the eye will be. The iris of the average adult eye is one-half the width of the white of the eye. Note that I said white—not the entire eye. You still have a bit of your eye left over.

Invert

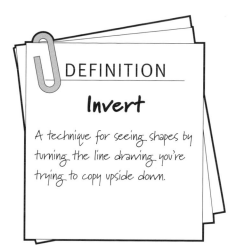

DEFINITION

Invert

A technique for seeing shapes by turning the line drawing you're trying to copy upside down.

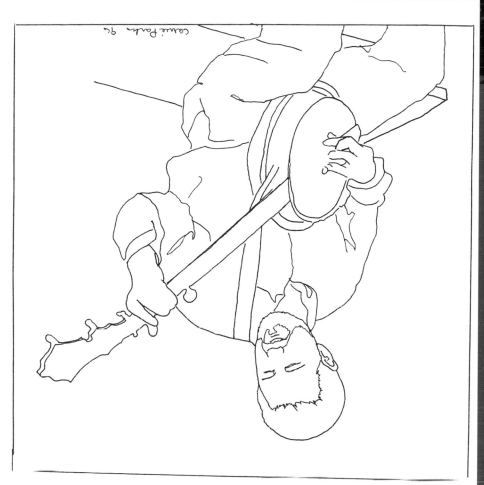

Another way to learn to see shapes is to invert, or turn, the line drawing upside down. Sometimes the mind can't make "heads or tails" (pardon the pun) of the picture you want to draw, so instead of looking for a specific feature, try completing your drawing using shapes. By working upside down, as shown in the example on this page, you focus on seeing shapes rather than the familiar image. Turning a photo upside down and checking your work is also a way to check for accuracy, which is covered in chapter six.

TIP The invert tool is an aid to help artists "see" better, however, it works best if used on line drawings. Turning a photo upside down and trying to draw it is quite difficult. Instead, use a line drawing to help you copy the image on your paper. The inversion tool is excellent training for anyone.

Rename and Incline

Rename

A tool for seeing the shape in facial features by renaming that feature in terms of shape.

object or situation has been given a name, and actions are made in terms of that name. For example, if you label a feature an *iris*, you will think of it as an *iris* and draw your memorized pattern of an *iris*. If you think of it as a *circle*, you will begin your drawing with a circle and draw the shapes you actually see.

Turning something upside down forces your brain to look for shapes. Even the verbal or mental act of referring to facial features within the image you're drawing as "shapes" is a way to train your mind. For example, when you refer to the iris, call it by its shape, a circle. By speaking or thinking of something in terms of shapes, you start to really see things in terms of shape.

Speaking is believing

In college I studied various theories of psychological thought. Though I never studied psychology and art together, there is at least one shared concept: labeling. In the behavioristic model of information processing, labeling is where an

DEFINITION

Incline

A tool for checking subtle angles in the facial features by using a ruler.

Facial features are not always symmetrical, and will vary from one side to the other. Eyes may be level with each other, or one may be higher or lower. Eyes may tilt up in the corner or down. Lips go up, down, wiggle about or curve. Unfortunately, people's eyes have difficulty seeing these subtle variations.

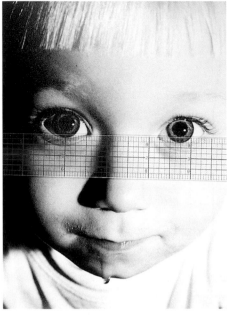

Enter the lowly ruler
The amazing plastic, grid ruler comes to the rescue for inclines. Using the side of the photograph as a vertical guide, you can place the grid of the ruler over the shapes of the facial feature and check to see what is where. The tilt of the eye is easy to see using the guidelines. Don't assume that you can see the subtle curve or angle of a shape.

Remember to rename
It is hard to realize the effect the labeling of a facial feature has on the way you think about it, but look at this pre-instructional drawing. The instructions were to draw a face. What was meant was to draw the entire head that includes the face and the hair—but to the artist the word "face" meant eyes, nose and mouth. Look how disproportionate this drawing appears. It is almost all "face."

Negative Space

DEFINITION

Negative Space

A tool that allows you to see a positive shape (solid space) clearer by focusing on the negative shape (empty space) next to it.

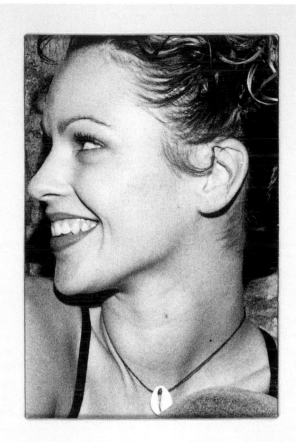

Negative space is defined as the empty space surrounding a positive (solid) shape. The whole of a picture is made up of positive and negative spaces (or shapes). People normally look at a shape and draw it—like a vase or a flower. If the drawing doesn't look right, they wonder how it became distorted. Artists, being the tricky folks that they are, pay attention not only to the subject (positive shape or space) but also to the "nothingness" next to that subject—the shapes created between the flowers or next to the vase.

I've been framed!

It's often easier to see negative space if it is framed by a viewfinder. A viewfinder places a box around something so that the edges of the subject touch the edges of the box. By looking through a viewfinder, you can more clearly teach your mind to concentrate on the true appearance of a shape. You can make a simple viewfinder by cutting a square out of a piece of paper. Look through the open area and you will see the world nicely framed.

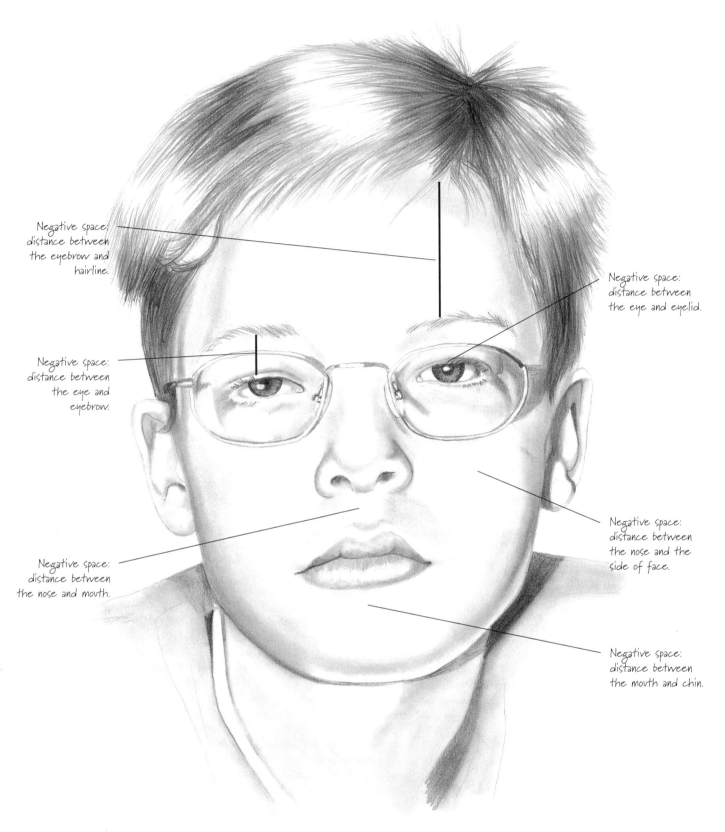

Negative space: distance between the eyebrow and hairline.

Negative space: distance between the eye and eyelid.

Negative space: distance between the eye and eyebrow.

Negative space: distance between the nose and the side of face.

Negative space: distance between the nose and mouth.

Negative space: distance between the mouth and chin.

Are you positive?

How can there be negative space on a face when the entire face is a positive shape? Actually, positive space is really the object you're drawing, and negative space is the area between those objects. Drawing the eyes and eyebrows means that there will be space between the two. This spacing is just as critical as the shape of the features.

When I look at certain shapes, I always check both the positive and negative shapes. For example, I will check to see if an iris is drawn correctly by checking the shape and size of the white of the eye.

Question

DEFINITION

Question

A tool for seeing angles and shapes more clearly by asking yourself exactly what it is you are seeing.

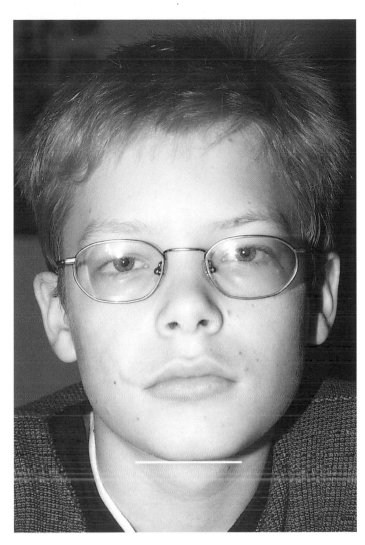

From the beginning
This tool is so named because you ask questions: What is the line/edge doing? In what direction is it going?

I was flying home late one night from teaching a composite drawing class. I had read every book I brought, I didn't enjoy reading any of the provided magazines, there was no movie and I was bored to tears. Fortunately, the young boy sitting next to me was also bored and was trying to sketch pictures from the flight magazine. They were very complex photographs. After watching him struggle for a few moments, I asked him if he wanted help. "Sure," he said.

He had roughed in a head shape, so I placed my finger in the neck area. (Simplify—I was literally pointing out the location and shape to the child.) I asked, "What does this edge do?" He replied, "It is going slightly downward and away" (from the face). He then drew that edge in the correct downward angle. I said, "Does it go downward forever?"

Child: "No, it changes direction and goes down the arm."

Me: "Where does it change direction?"

Child: "Right here" (pointing to the location).

We had identified the shape and the location on the drawing where something was different. The particular spot on the photo we were drawing was both measurable and locatable using optical indexing.

Using this questioning technique, the child was able to complete a very complex drawing of a model. My finger on the location on the photograph and my verbal questions required the child to both see that information and articulate what he was seeing. The resulting drawing was quite remarkably skilled.

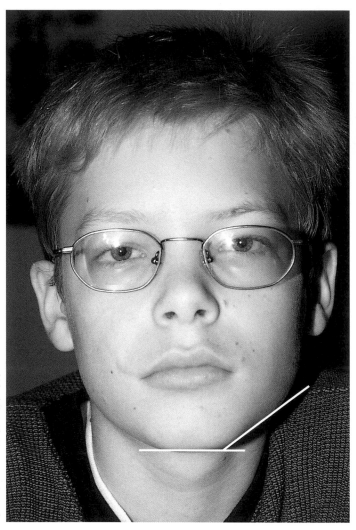

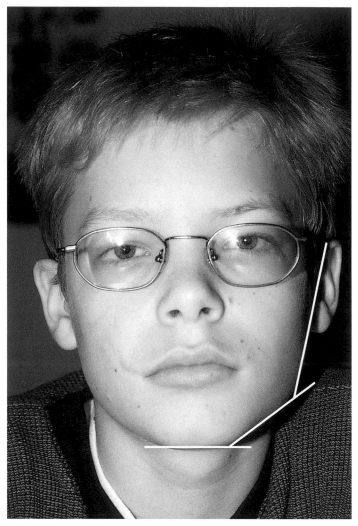

Does this line go on forever?

As you are drawing the first line in one direction, the face eventually has another angle, and your line goes too far. Something has changed, so you might ask, "What happened?" In what direction is your line/edge going now? Your final question is, "Where on the face did this change occur?" Asking questions makes you articulate certain points and locations that are not guesswork or trial and error. They can be seen, but first you have to know what you are looking for.

Angle checkpoints

The average face tends to have certain places where an angle would be located: the transition between the chin and jaw, the jaw and cheekbone, the cheekbone to temple and the temple across the forehead.

Compare

DEFINITION

Compare

A tool for seeing shapes more clearly by tracing that shape from the photograph, tracing your own drawing and comparing the two shapes as line drawings.

It's often a struggle to make a drawing and a picture look alike. This is especially true when you are drawing a family member. It may be that the mouth is causing the difficulties, so you draw it again. And again. And again. The paper starts to thin in that area from all your erasings. You may become frustrated because you can't see what the problem is in that shape.

Drawing is difficult at times, especially when the shapes you see are subtle. There is a simple solution to helping your poor, beleaguered brain see the elusive shape: the compare tool.

Make your drawing look real

1 Cheat

Place a sheet of tracing paper over the photograph and trace the outline of the shape causing the difficulties.

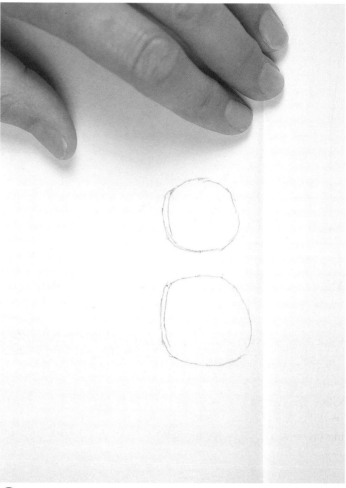

 Trace again

Move the tracing paper over to your drawing. Place your hand over the tracing you have just done, so you can't be influenced by it. Trace the same shape on your drawing that is causing you problems.

3 **And the answer is...**

Move your hand over, and look at the two shapes side by side. You have removed the "background noise" of the information-rich photograph and created the shape in its simplest form. The subtle difference between the shapes is apparent when you compared it in this manner.

Flatten

DEFINITION

Flatten

A tool for seeing a three-dimensional shape more clearly by closing one eye to level the image into two dimensions.

You previously learned how to take a three-dimensional image in front of you and transform it into a two-dimensional image on your paper by closing one eye. This is true for finding the site or location of an object as well as the shape of an object. A facial feature, like the nose, can be difficult if you don't flatten it by closing one eye.

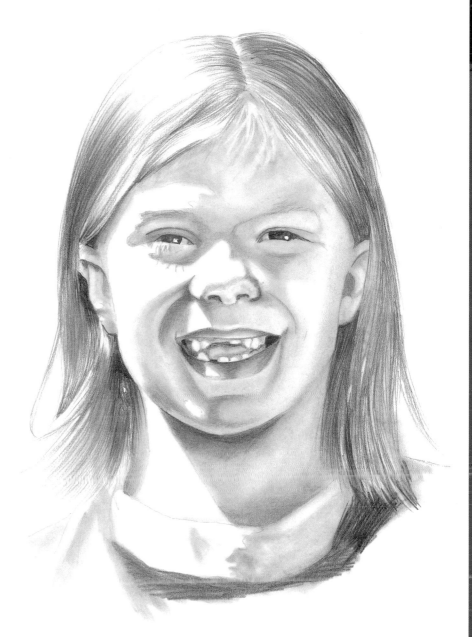

By closing my one eye, I was better able to translate this three-dimensional image to my two-dimensional paper. Without this technique, Aynslee's image would most likely have looked strange and out of proportion, almost like looking into one of those carnival mirrors.

AYNSLEE
12" × 9" (30cm × 23cm)

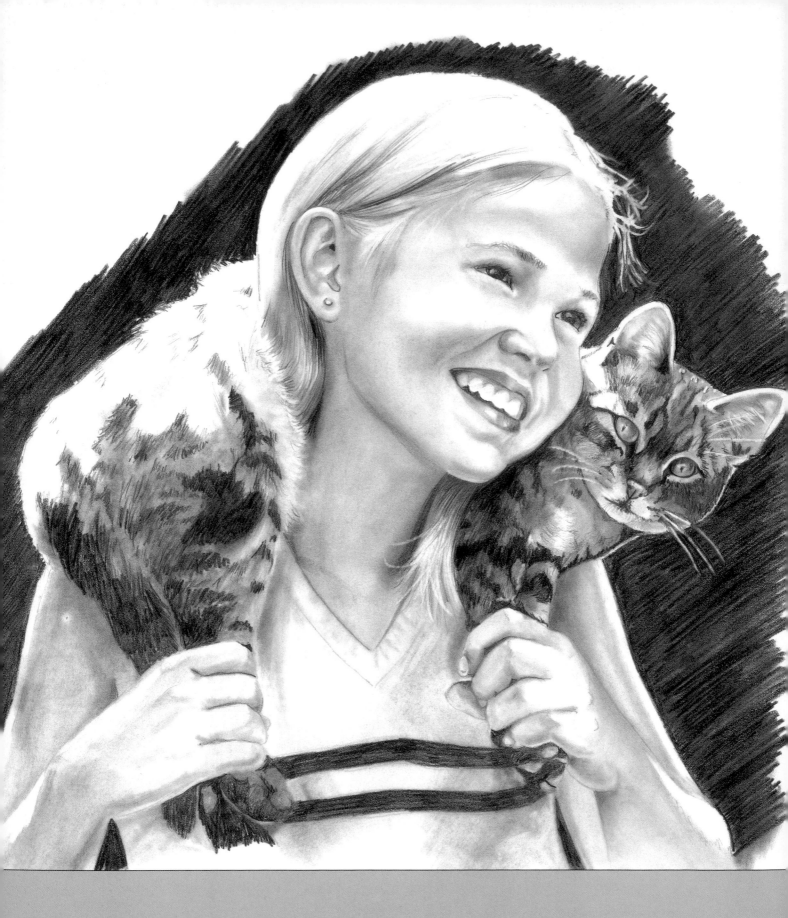

Shade

CORRINE
16" × 20" (41cm × 51cm)

Probably the single most requested topic my students ask for is information about shading. How do you make something look real? This chapter covers techniques on how to "see" shading and the correct shading that is specific to each feature.

Understanding shading is the critical step for taking a line drawing and transforming it into a lifelike work of art. Shading brings a three-dimensional quality to the drawing. Traditional training in shading at most art schools involves an instructor placing a variety of white objects such as balls, plates, sheets and boxes on a table with a light on one side and then telling the horrified students, "Draw this." If your instructor was somewhat enlightened, he or she might give you a clue like "squint." Yeah, right. Your brain tells you that the objects are shapes, white, different from each other and, er, well, white... After all, if you could draw stuff like that with no instruction, you could have saved yourself the class fees.

Understanding shading tools

To understand shading, you need to know three things: What to look for, how to evaluate what you're seeing and any useful techniques to make your drawings better. The only additional tip for shading your drawing is practice. Shading involves hand-eye coordination. Emerging artists have trouble with shading not because it is more technical or difficult; they struggle because it requires new physical skills that come with practice.

Shading involves training the eye to see what artists call "value changes." Value means the lightness or darkness of a color. A value change is where something changes from light to dark or vice versa. The five tools you will learn are:

- Values/Lines
- Isolate
- Compare
- Question
- Seek

Shading techniques

There are many techniques for shading, including varying the pencil direction, making linear strokes, building up lead and smudging the lead. I prefer the shading technique of smudging the lead. Smudging requires a smooth paper surface. It has a few tricky areas, but it's faster and requires less pressure and control of the pencil.

Rub a dub-dub
Smudging requires a paper stump or tortillion (see chapter one). The stump is just rolled paper with nothing on it. You use it to pick up lead (graphite) from one area of the drawing and blend it out. The paper needs to be smooth, plate-finish bristol board or illustration board. Textured paper is better for other techniques because it snags the lead.

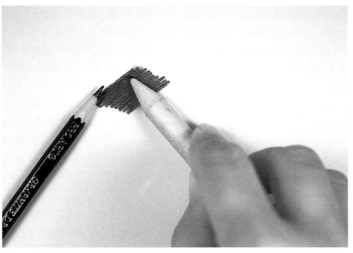

The fine art of smudging
The lead may come from the drawing itself or by scribbling on a piece of paper with a soft pencil (2B-6B work well). As you pick up lead and move it around with the paper stump, it gradually gets lighter as the lead is worn off the stump. This is why it's easier to smudge—the tool is helping you maintain the correct amount of lead.

Hold it right there

This is the standard way you hold your stump. It *only* works if you are smudging a small area. Use the tip of the paper stump for these small areas. You will use the stump's tapered side, held flat against the paper, for larger areas. Place it across your flat hand and smudge using the tapered area.

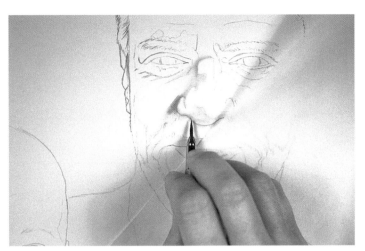

Keep your grubby fingers off

Your hands contain oils that will transfer to the paper, causing the paper to react with the graphite in adverse ways. Place a piece of tracing paper under your smudging hand as shown here.

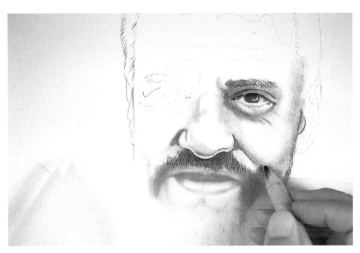

The white stuff

Preserve the white areas of your drawing. Remember that you are grinding lead into the paper, and though the paper is smooth and cleans up well, you want to keep from grinding lead into the areas you know will remain white. Work from your dark areas and blend toward your lighter areas.

The long and short of it

To make the skin on the drawing look smooth, use long smooth strokes on your paper. Short, jerky strokes make for bad skin. If necessary, go outside the edges of the face and erase later. (I know, I know, I just told you to not smudge where you want to retain the white areas, which might be outside the face. That's okay. Sometimes you need to break an art rule to achieve a goal—in this case, smooth skin.)

The same holds true for your original pencil shading—long, smooth strokes applied with an even hand make for smooth skin and hair. I'm starting to feel like a commercial.

Layers

When you smudge, you lift a small part of the lead from one area and transfer it to another. This means that not only are you blending into one area, you are lightening another. Smudging is not a one-time application. You may need to go back and darken the original area again and apply layers of blending to get the right value.

Step-by-step shading technique

Using the right pencil hardness, pressure and stroke make a terrific difference in your shading. You cannot go back and try to blend a zig-zag black line done with a 6B lead. You will end up with a zig-zag smudge.

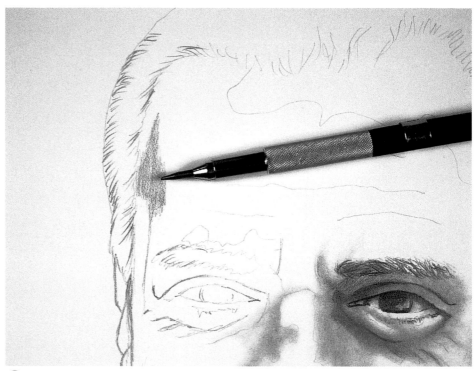

① Establish an edge

Start with an HB pencil. Using the side of the face as an example, evenly scribble a smooth, continuous tone next to the line that represents the side of the face. Keep your pencil on the paper and the pressure on the pencil even and steady.

② Apply even pressure

Take your paper stump and blend into the face using long, smooth strokes.

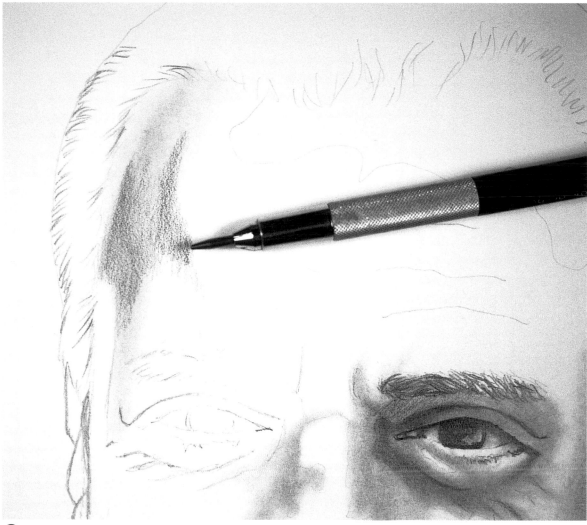

③ Repeat as necessary

Your goal is to not go immediately to the finished value but to build values up on the face. You may need to go back and add more lead, smudge again, add more lead and smudge again.

Shading techniques summary

- Use smooth paper.
- Use the right tool.
- Hold it correctly.
- Keep tracing paper under your hand as you smudge.
- Preserve your white areas.
- Use long strokes for smooth skin.
- Keep applying more dark layers as you smudge.
- Use even pressure and smooth pencil strokes.

Values/Lines

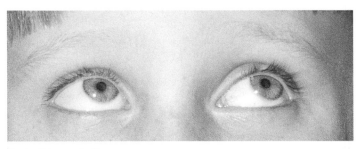

Eyeball to eyeball
A close examination of the eyes, for example, will show us that the bottom lid is a shelf. This shelf picks up light and is light in color. You see it often because it is actually lighter than the so-called white of the eye. There are no lines on the bottom lid; it's a series of value changes.

Now we will delve into the deep, inner psychology of art, asking the age-old question, "What is a line?" When you draw, you usually start with lines to tell you where you are on the paper and where the edges of various items occur. Beyond algebra and other math applications, you have probably never thought any more about lines. Your brain, however, loves lines and will lie to you about them.

It's true. In chapter two, you learned that the mind places everything into patterns of perception, memorizes that pattern and uses that pattern instead of the reality of what is actually present in the photo. Your mind figures it knows all about things like facial features and therefore will provide information about that feature, regardless of reality. Perceptions are more powerful than facts.

Drawing lines represent one of two things: a thin, dark value on the face (such as the crease in the eyelid) or a value change. A line in the latter instance

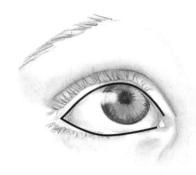
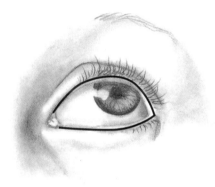

I got you, babe
Because your mind tells you that there is a line on the bottom lid, you draw it in. This is fine if you're drawing Cher, circa 1965, "I Got You, Babe..." but it is incorrect for most other eyes.

Look at this illustration. Your mind accepts the lines you originally use as correctly defining the shapes of the face. Your mind (perceptions) really likes those same lines and will leave them in place at the end of the drawing.

shows where a dark and a light value come together. Here's a secret: There are few true lines on the face. Most of the shading on the face comes from value changes, not lines. When you draw lines to indicate value changes, you tend to leave the lines in place. I think of this as Carrie's Dictum: The closer in value two shapes are to each other, the less you can draw a line to separate them.

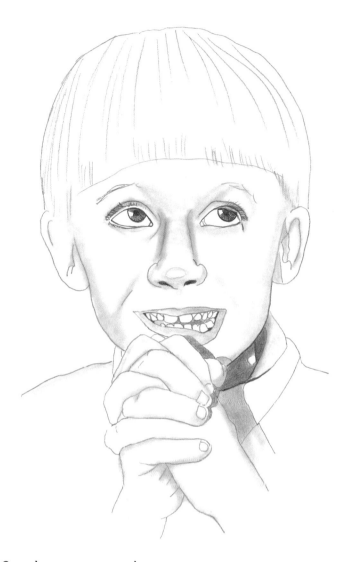

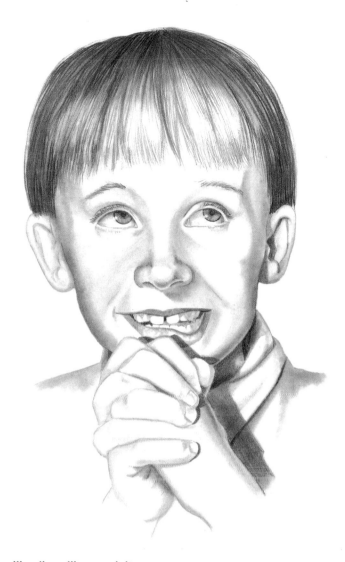

Once drawn, never erased

Look at this drawing. You know it is incorrect, and certainly doesn't appear real. But what's the problem? Your mind has accepted the lines as reality, but they are not really there and so you are frustrated.

Handling lines like an adult

You have two choices when shading: Either kill the line (that is, shade up to the line and make the line disappear because it's now the same shade at that point), or don't draw the line in the first place.

Line killing

The side of the face is an example of line killing (and you thought this was a nonviolent art book). You do have to draw the side of the face originally with a line, but there is no line there. You see the face because it is either lighter or darker than whatever is beside it. Dark hair, for example, forms the side of the face. The face may also get darker as it reaches the edge. This is not a line, mind you, but a tonal change. Therefore, shade up to the line and make it disappear. This will indicate that the area is now all the same value.

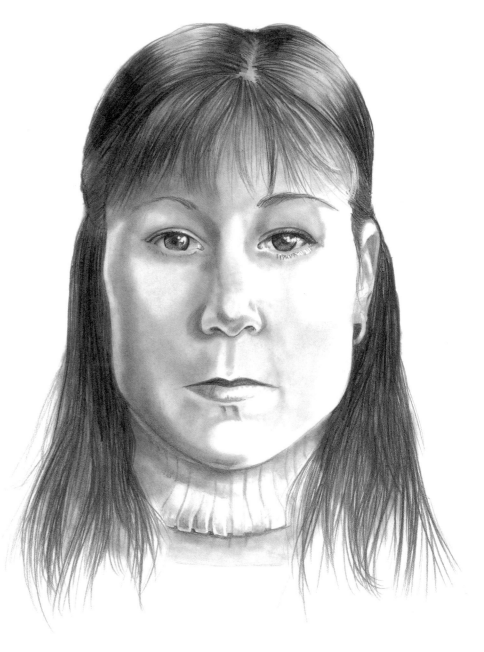

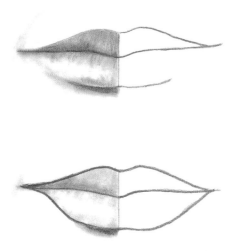

No line at all

Better yet, given your mind's ability to deceive you, don't draw some lines in at all. The upper lip has qualities that you may need to originally draw, but watch that lower lip. It's not necessary to complete the lower lip as a line. You need only indicate where the lip ends and the shadow begins.

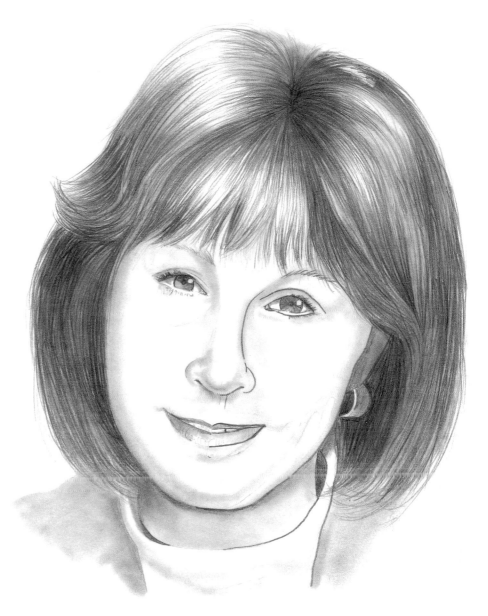

Problem areas

The most common problem areas in using lines to separate value changes are the lower eyelids, the sides of the nose, the edge of the face and around the lips, in particular the lower lip. These areas contain no lines and should not be sketched as linear separations. Either kill the line by absorbing it into the shading or don't draw it in at all. Notice how odd the right side of her face looks with the lines left in the drawing.

SUSIE
12" × 9" (30cm × 23cm)

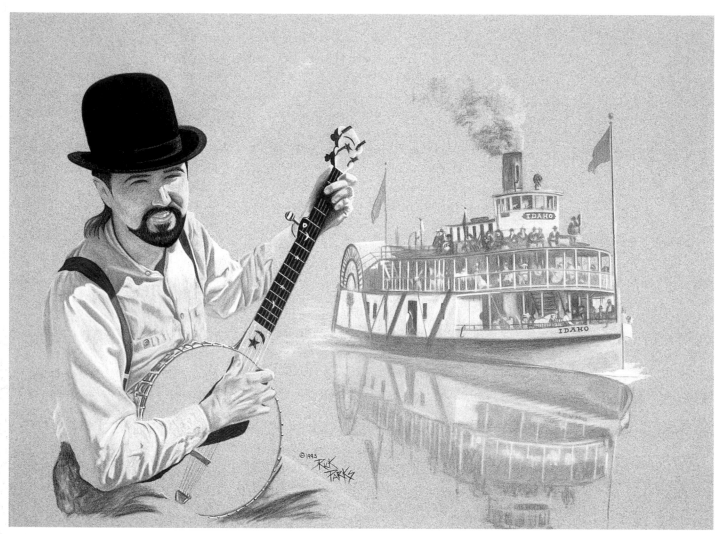

It doesn't have to make sense

My husband, Rick, wanted to do a self-portrait showing himself as an old-time riverboat banjo picker. He got permission from the local museum to use a historical photograph of a riverboat. As Rick was shading in the riverboat, all he saw were dabs of light and dark on the deck. When he took a break from his drawing and stepped back, the dabs became people. He didn't try to make the dabs look exactly like people; it was correct and real in the photograph. After he had used the questioning technique, he came to realize he couldn't make it "more correct" or "more real" by applying reasoning to it. Don't try to argue with reality. Draw what you see, where you see it, to the correct shade.

Seek

I have a confession: My husband, whom I adore, loves the banjo. There, I've said it. He studies the banjo. He plays banjo and bluegrass music *in my presence*. He takes banjos apart. He knows who made what banjo, the year each was at its peak and every major banjo picker in the world. Rick can walk into a music store, a pawn shop, a garage sale, an attic or a

living room, see a banjo and know everything about it in seconds. He knows what to look for. Why am I rattling on about banjos? All of you know (or are married to) someone who has this same ability—though it might be cars, guns, dogs, (I can do this with Great Pyrenees), sports teams, clothes, hair styles or antiques. You know what you're looking for. Your eye is trained to seek some particular detail that is totally obscure to the average person.

Artists, too, seek one particular detail when they work on their art. Artists seek to find something round or rounded in a subject. Why seek? Because artists have learned that round shapes have a particular shading pattern. If you know the shading pattern of a rounded surface, you will know what to look for in the photograph. Even if it is not clearly present in the photo, or is missing altogether, artists know that if they include this pat-

tern in their drawings, that feature will appear rounded.

In fact, some artists draw using only rounded or round shapes. They think in round. They teach in round. They illustrate in round. The problem with drawing and locating features using rounded shapes is that curves and curving shapes vary. My students, in their original drawings, will always err where there is a curve in the drawing, not where there is a straight line. Locate using straight lines. Think shading in curves.

OK, so now you are going to throw out the fact that I just said if you don't see it, don't draw it. This is the exception that proves the rule...or something like that.

The face has many rounded surfaces. If you know the shading on a round surface, and you know where the face has rounded areas, you will know how to shade the face better.

Round shading pattern
The ball has a pattern that is as follows: lightest light, which is the highlight; dark, which is the shadow area; reflected light, which is light bouncing off the floor or from other objects; and a cast shadow, which is the shadow that is created by the object.

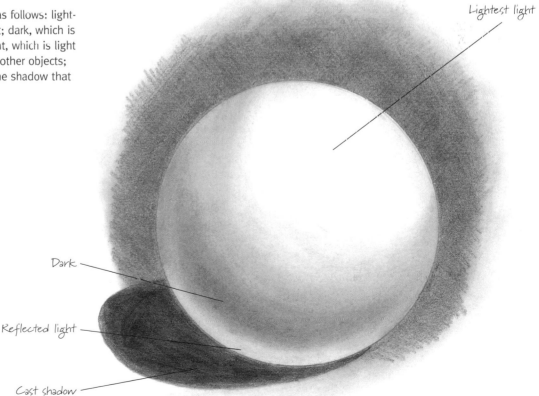

Lightest light

Dark

Reflected light

Cast shadow

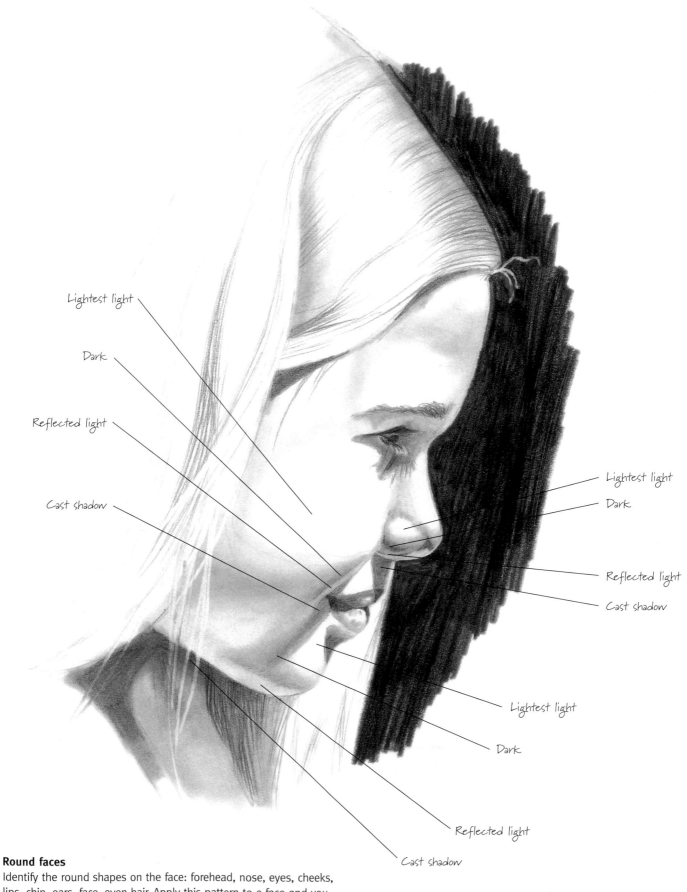

Lightest light

Dark

Reflected light

Cast shadow

Lightest light

Dark

Reflected light

Cast shadow

Lightest light

Dark

Reflected light

Cast shadow

Round faces

Identify the round shapes on the face: forehead, nose, eyes, cheeks,
lips, chin, ears, face, even hair. Apply this pattern to a face and you
will make it round: lightest light, dark, reflected light and cast shadow.

The seek tool works especially well here. There are many rounded sur-
faces that contain the particular shading pattern of: lightest light,
dark, reflected light and the cast shadow.

COURTNEY
12" × 9" (30cm × 23cm)

73

Checking for accuracy

The final general drawing principle is to check your work for accuracy. As you work, your mind is processing and placing your drawings into patterns of perception. After a fairly short amount of time, you will no longer really see your work. You need ways to break that pattern of perception. It's like proofreading something. You tend to miss the typos and other errors, but you can correct this by having someone else read it or by reading it aloud.

Many artists already use one or more techniques to check the accuracy of their art. These two pages are a summary of many of these techniques. I advise you to incorporate one or more of the following techniques into every work of art you do:

- Invert
- Distance
- Time
- Tools
- Reverse
- Friend and family factor
- Other artist factor
- Combination

Invert

Inverting your art simply means to turn it upside down so that it looks different. Turn both your drawing and the original photo upside down and place them side by side. You may see any errors or problems more clearly.

Distance

Whenever I complete a watercolor or drawing, I place it at a different distance from which I painted or drew it. I usually prop it across the room and study it from afar. Changing the distance alters the way the art looks. I recall one flying osprey painting I propped in just such a way. It looked fine, but something was bothering me. After a day of walking away, walking back, wandering around the room and sneaking peeks at the painting, I realized that the wing was bent at the wrong angle. I made a simple correction and this piece was accepted into a juried show and the traveling show as well.

Time

Because your mind has placed the drawing into a pattern, if you walk away from that work, you will see it differently when you return. I often take a drawing away from a student, wander about the room for a minute or two, then hold it at a distance for the student to see it with fresh eyes. Build in breaks away from your work. Caution: When you first return to your drawing, immediately write down the corrections you see or you will forget.

Tools

There are tools that will help you see better. Many artists think it's cheating to use a tool to help them draw. That's like thinking a hammer is cheating because it helps you to work faster. Tools are just that—physical aids to make you a better artist. One common tool is a ruler for checking for angles. Another tool is a piece of red film held in front of your eyes. It will block the art into values and will help you make those corrections. Other tools will show you shading, angles and perspective. You may purchase some of these tools or make them yourself.

Reverse

Holding art up to a mirror is a long-standing artistic technique. The reverse of the art shows some problems more clearly.

Friend and family factor

Sometimes you can't see it but others can. Ask your friends and family members what they think of the work. I remember asking my (non-artistic) mom for her opinion on a painting I liked. She said all she could see was the blue blob of paint on the nose. She missed my wonderful art because a blue blob captured her attention (and assuming my purpose was not to express my feelings on noses, blue blobs, or a commentary on Rudolph the Red-Nosed Reindeer), her observation made me revisit the painting.

Other artist factor

Critiques are useful for getting outside input on your work. They help you see the art with fresh eyes. My husband is an artist, so I have a built-in radar on my art. Of course, it is not good having your husband stare critically at your work, then incredulously state, "You're not done yet, are you?" This may not make for the most harmonious marriage.

Combination

Of course, a combination of the accuracy techniques is an artist's best bet. Each of my composite sketches and paintings receives a combination check for accuracy. With my composites, I prop the drawing on the table at a distance, take a break, return and place the drawing on the floor and walk around it. I ask the witness to take a break and then recheck the drawing from a different distance when he or she returns.

Walking away and taking a break helped me iron out some of the intricate shading issues in this drawing. Sometimes all you need is a little time for everything to click.

JB & COLE
16" × 20" (41cm × 51cm)

Drawing Eyes

So much has been written about the eye. Henry Theodore Tuckerman wrote, "The eye speaks with an eloquence and truthfulness surpassing speech. It is the window out of which the winged thoughts often fly unwittingly. It is the tiny magic mirror on whose crystal surface the moods of feeling fitfully play, like the sunlight and shadow on a quiet stream." Given that the eye is indeed the window of the soul, artists need to get the window right.

Eyes as shapes

Eyes are shapes, so you will use the shape and shading techniques to help draw them better. This section is the practical, step-by-step application of the various techniques presented in the first few chapters. You will isolate the feature of the eyes, simplify the shape and rename the parts of the eye as shapes.

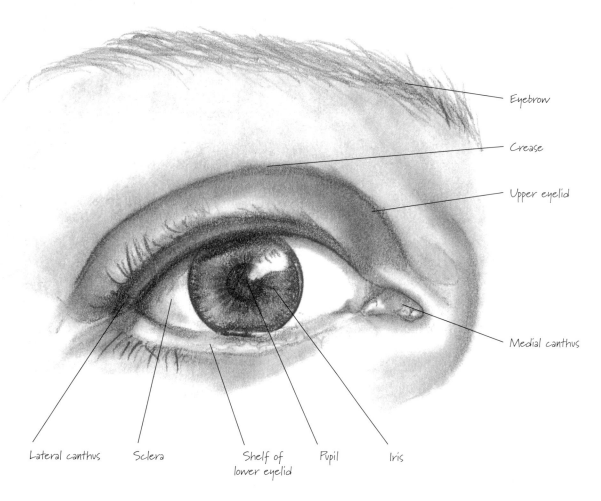

Eyebrow

Crease

Upper eyelid

Medial canthus

Lateral canthus Sclera Shelf of lower eyelid Pupil Iris

The parts of the eye

Locate and measure the eye

① Start with a line

You will need a ruler, a circle template, a pencil and an eraser to do this exercise. Draw a line 7½-inches (19cm) long. Break it up into 1½-inch (4cm) sections. This will become an imaginary line running across the eyes. You learned earlier that there are "five eyes" across the average face: an eye between the side of the face and the eye, the eye itself, an eye between the eyes, a second eye and the space between the eye and the side of the face.

② Look for the incline

When you draw a horizontal line through the eyes, from the outside to the inside corners, it's immediately apparent if the eyes are level, one higher or lower, or tilted at the corner.

③ Subtract out the doohickey

You probably thought the inside corner of the eye was called the medial canthus. I call it the doohickey. On most people, it is a small, triangular, pinkish area in the inside corner of the eye. Now that you know it is the doohickey, you need to ignore or subtract out that measurement.

Don't forget to center it

Now that you have established the initial measurements, you must find the center of the white of the eye—not the center of the entire eye (remember you are ignoring the doohickey). This is where you center the iris. You might need to refer back to pages 46-48 to refresh your memory on how to draw a correctly proportioned eye.

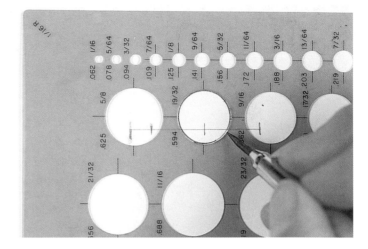

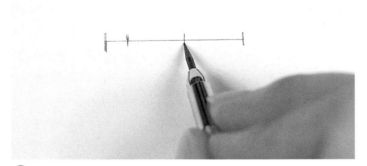

1 Looking for circles

The iris, on the average adult face, is one-half the width of the white of the eye. You could fit two irises into the white of the eye, as shown in the photograph above. The point where the two circles touch is the center. Mark this point.

2 Place the circles

The circle of the iris is not centered on the line you've drawn from top to bottom; about one-fourth of the circle extends below the line with most of the iris above the line. Find a circle in the template that is one-half the width of the eye. Draw that entire circle, using the center mark you just made.

❸ Apt pupils

You will be repeating the process you learned on page 47, but let's review it one more time. Using the marks at the top, bottom and sides of the circle template, connect the lines to find the center of the circle. Center the pupil of the eye in the middle of the iris.

Relate

This is a good place to stop and revisit the topic of "relate." Remember, this means that once you have a shape, you can relate other shapes to that shape. The circle of the iris is a good example. Another feature you can relate shapes to is the upper eyelid. Notice where on the circle of the iris the eyelid touches. On wide-open eyes, the entire circle shows. On average eyes, the lids are above the pupil. "Sleepy eyes" show very little circle (see page 84). Don't vary the circle to fit into the eye; vary the lids according to the iris.

Wide-open eyes

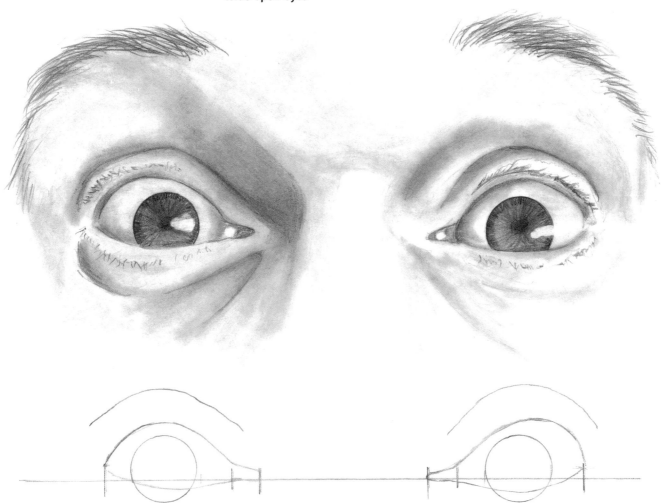

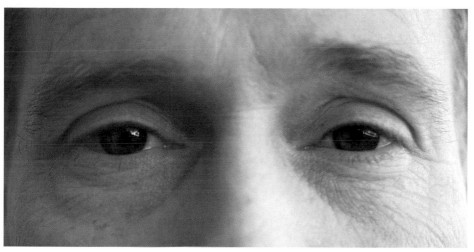

Average eyes

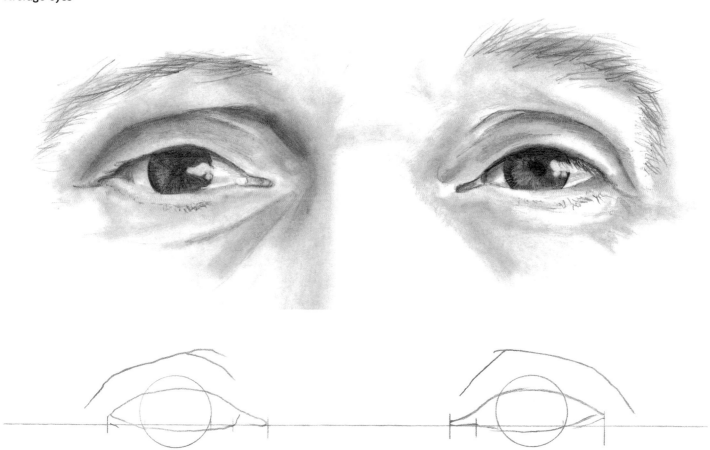

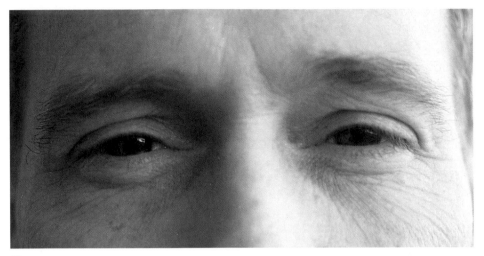

Sleepy eyes

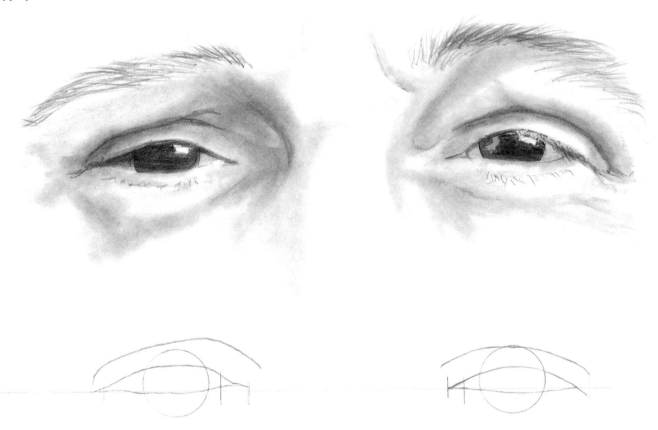

Eyelid creases

Above the eye, the upper eyelid forms a crease. In the average eye, this looks like a line following the upper eyelid. When the crease is very high above the eye, it's called "heavy lids." When it's very close to the eye or doesn't show at all, it's called "overhanging lids." Pay close attention to the location, direction and appearance of the upper lid crease.

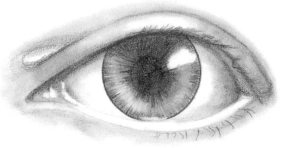

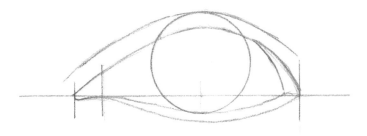

Average eyes

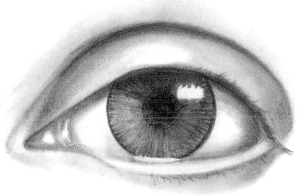

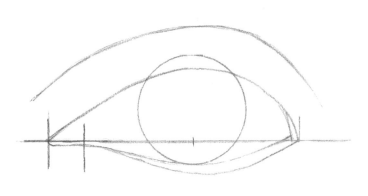

Heavy lids

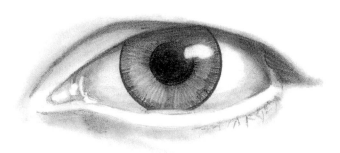

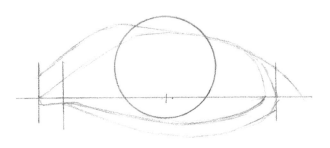

Overhanging lids

Lower lids

Both the upper and lower lids have a thickness to them, as shown in the drawing to the right. The upper lid's thickness is indicated by its cast shadow and by the appearance of an edge in one corner. The lower lid is a shelf that will often pick up light. If fact, in the outside corner of the eye, the shelf of the lower lid is often lighter than the white of the eye. Make sure that you haven't made the shelf a single line, and that your lines aren't showing when you are done shading.

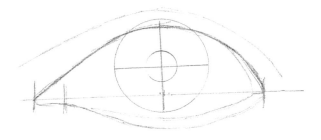

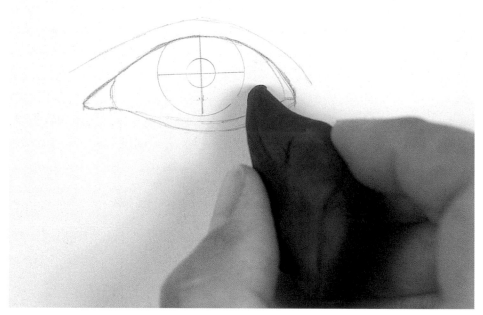

Keep it neat

Before shading the eyes, erase the interior guide lines you have made. Leave the crosshairs in the iris, as you can use them in shading.

Eyes contain one or more highlights in them. To keep your whites white, leave these areas white rather than try and erase out the highlights.

Finish the eye with flair

Back to the step-by-step demonstration. You will need to incorporate all of the lessons from the last few pages, so don't be afraid to go back to the information at any point.

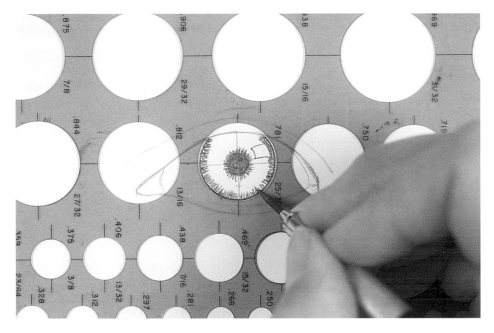

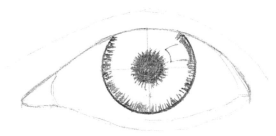

1 **Shade the iris**

To keep the circle of the iris neat, leave the circle template in place initially as you shade. After filling in the black pupil, fan outward with a dark pencil to keep it from looking so stark. Go around the outside of the iris (with the circle template in place), and fan inward for the same reason.

Pay close attention to the contrast between the black pupil and the color of the eye. Because you're drawing in black and white, it's the contrast between the black pupil and the shading on the iris that you see. With some very dark eyes, you won't see a separate pupil and an iris—it's all dark. Some eyes have a darker rim on the edge of the iris.

TIP *Shade outward from the black pupil to the edge of the circle template. This will enhance the appearance of the eye.*

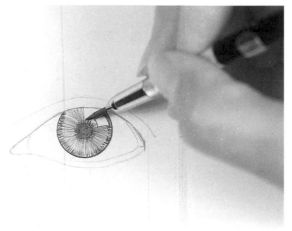

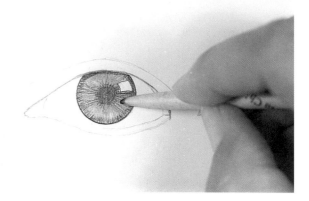

② Fill in the iris

The iris is made up of linear shapes fanning out from the center. Using an HB pencil (on lighter colored eyes), fill in between the pupil and the outer rim. Keep the highlight white. Then, use a paper stump to blend the shading together, again saving the highlight. On dark-colored eyes, use a darker lead to fill in the space between the pupil and iris edge.

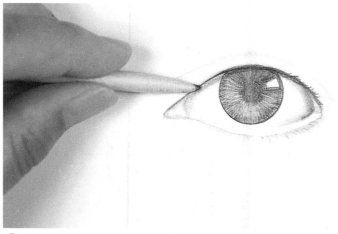

③ Shade the eye

Using the paper stump, place the shadow cast by the upper lid, and a shadow in the corners where the "ball" of the eye goes back into the head. Erase and absorb the lines of the lower lid into the shading.

④ Add the finishing touches

Finally, use your kneaded eraser to lighten the iris on the side opposite of the highlight. This creates the appearance of light passing through the transparent cornea.

Eyebrows and eyelashes

Eyebrows are made of short hairs. Interestingly enough, a pencil stroke is shaped like a hair; fat where it starts and tapering off into a thinner end. "Comb" eyebrow hair with your pencil—place the pencil lines in the direction the eyebrow hair grows.

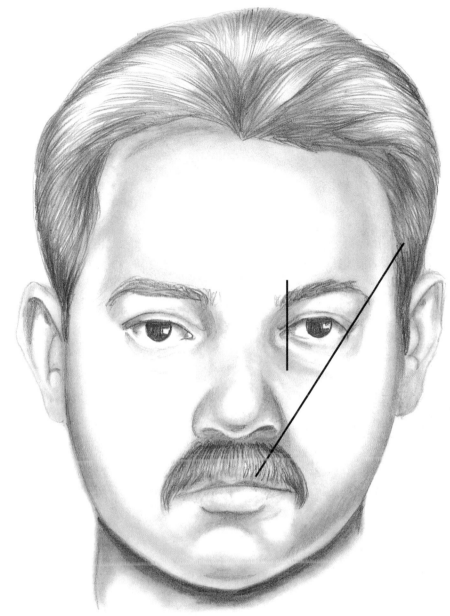

Eyebrow location
Eyebrows vary quite a bit. Most start at the edge of the eye and end in a line that runs from the nose past the eyes.

Eyelashes
You generally won't be able to see eyelashes when you look straight on at most eyes. The exceptions to this are mascara-coated lashes and very heavy, long lashes. The lashes come forward and curl upward, appearing as a ragged edge. One way to imply long lashes is to place their shadow into the highlight of the eye.

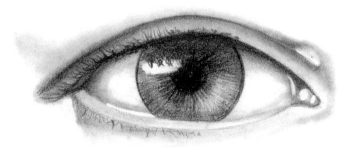

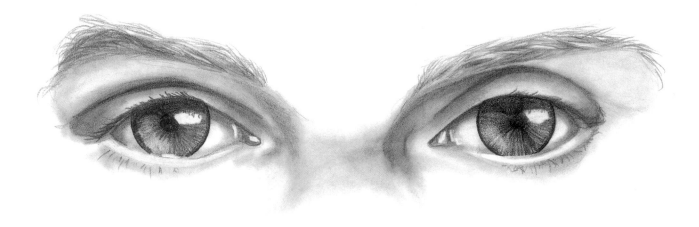

Eyebrow shape

Eyebrows may curve, be straight, close to the eyes, have a bend in them or arch high or low.

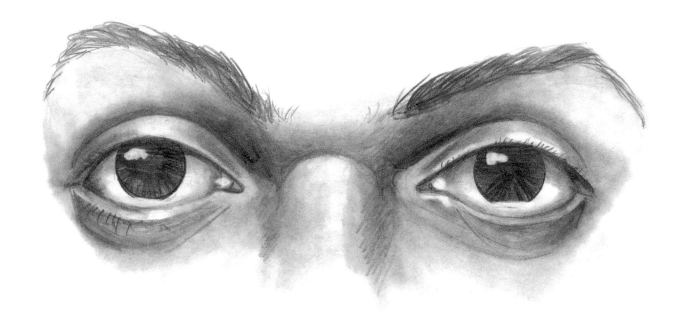

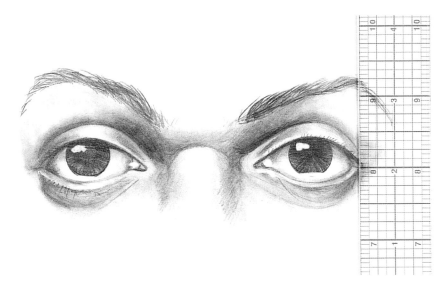

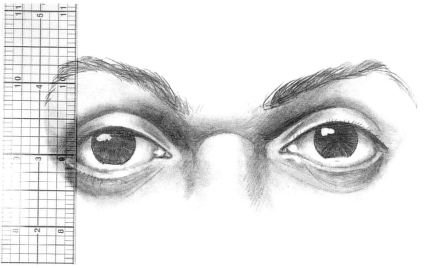

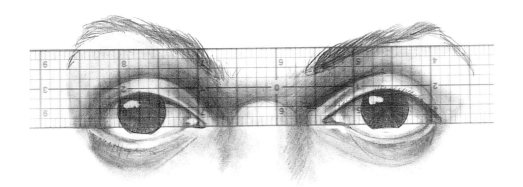

Use your tools!

Once again, use the tools for "seeing" that you have learned about in the past few chapters. Eyebrows have a site that you can determine by measuring. As shown in these three photos, place a ruler next to the eyebrows to see their incline. Then use the eyes to relate the location of the curve of the brows.

Examples of completed eyes

So, you think you have learned how to draw every eye, huh? Not so fast! You must also take into consideration how varying eyelids and eye shapes can change the appearance of irises and eyelashes. Study the next few examples, and see if you can point out the differences between them.

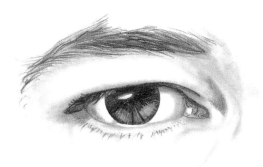
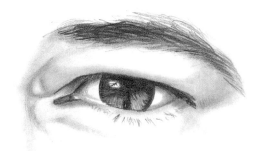

Overhanging lids of a person of European descent

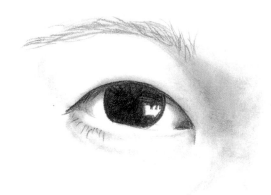
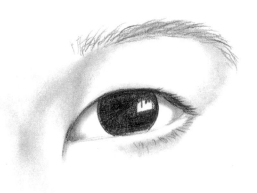

Overhanging lids of a person of Asian descent

Iris raised

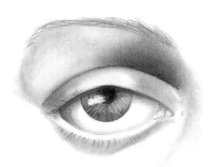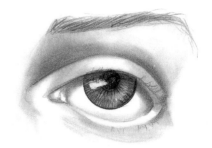

Bulging eyes

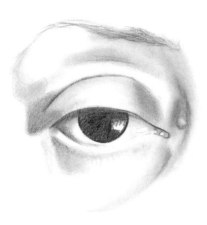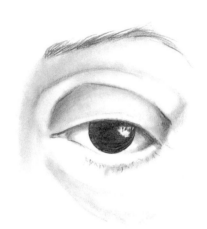

Deep-set eyes

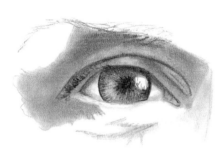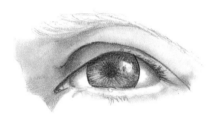

Heavy eyes

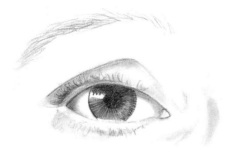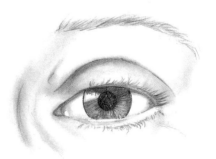

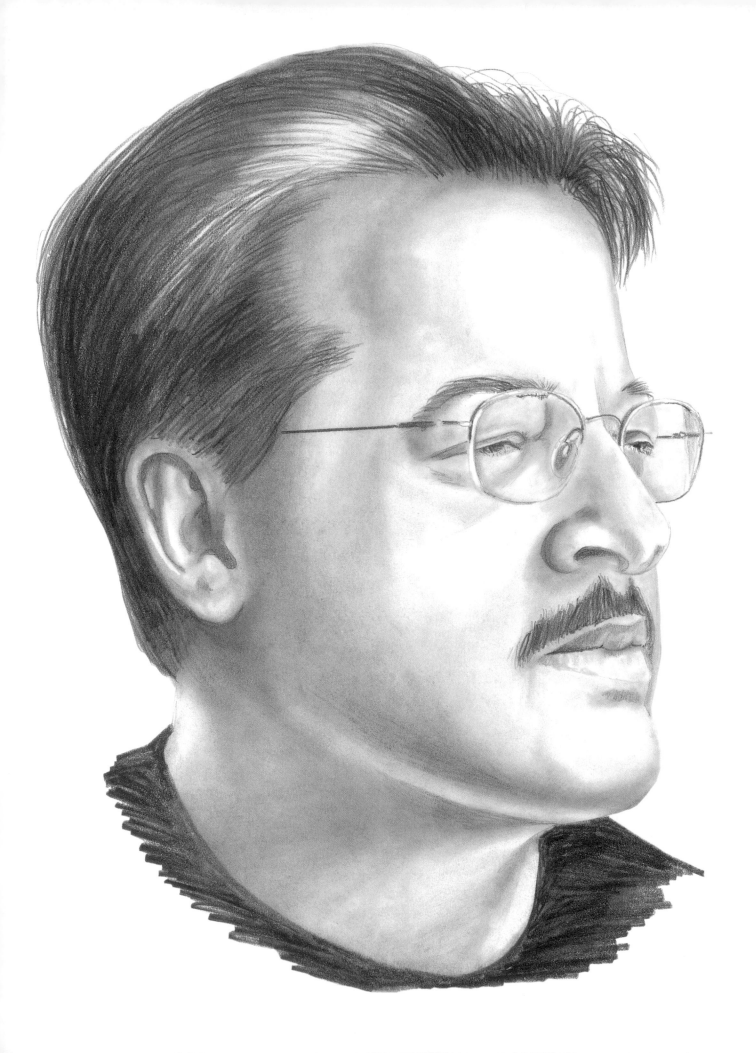

Drawing Noses

CRIS HARNISCH
12" × 9" (30cm × 23cm)

You might have noticed that few poets have waxed eloquently on the nose. Even emerging artists seem to stumble when it comes to drawing noses. If much of this chapter seems remedial, it is because the nose needs more attention... you don't want to blow it. OK, a number of puns and nose comments are running through my mind. I admit this is a hard chapter to write. But noses are really quite simple to draw once you understand the structure of what you are looking at.

Know your nose

Once again note that noses are shapes.
As seen in the illustration, the nose shape
is created from two rounded shapes: the
ball and the column. The nose is not cre-
ated from lines.

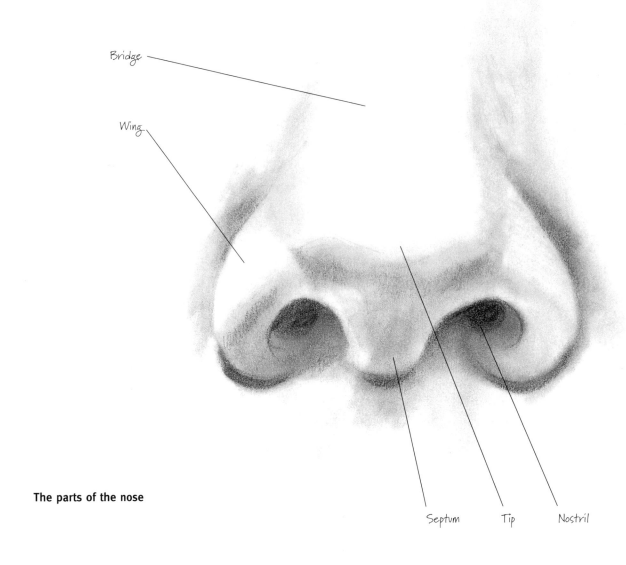

Bridge

Wing

Septum Tip Nostril

The parts of the nose

One shot

Look at your photo and try to find the multiple shapes that
make up the nose in that one image. Drawing a nose will
become much easier once you have identified all the indi-
vidual parts that create the total image.

Nose site

Note: I am referring to the average nose in the following description.

The site of the nose is contained within a rectangle that begins in the forehead. It is as wide as the inside corner of the eyes on the female face (shown on the bottom left) and the start of the white of the eye on the male face (shown on the bottom right). Most people make the nose too long and too narrow. This is because the nose causes the artist to over-rule what he or she really sees and perceives to be true. The nose starts in the forehead, but artists really don't pay attention to it until it is level with the eye. They therefore draw the nose the correct length from the eye down to the tip, not from the forehead, and the resulting nose is too long. Most books also show the male nose as too narrow—the width of the nose on the female face. Male noses are wider.

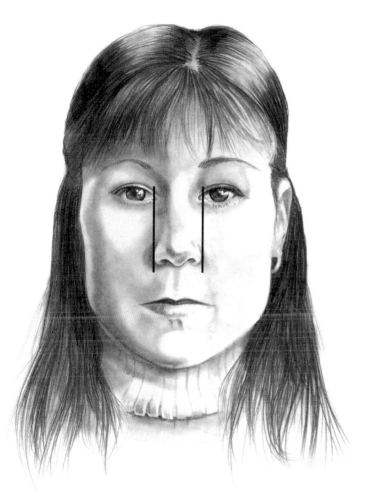

Female
Notice how the width of the nose begins at the corner of the eyes.

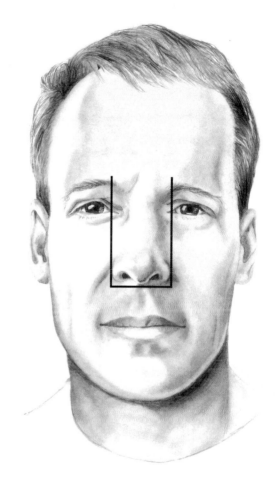

Male
The width of the nose is bigger; it starts at the white of the eye.

Wing site

The wings of the nose are about one-third the height of the nose, if you measure from nose tip to the top of the eyebrow, as shown in this drawing.

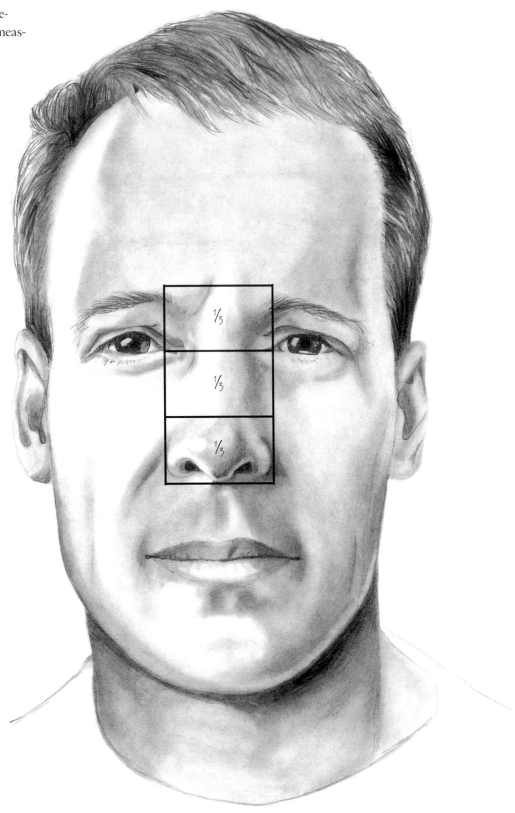

Basic wing shapes

The wings of the nose may be round,
flared, flattened or any combination of
these shapes (as seen here).

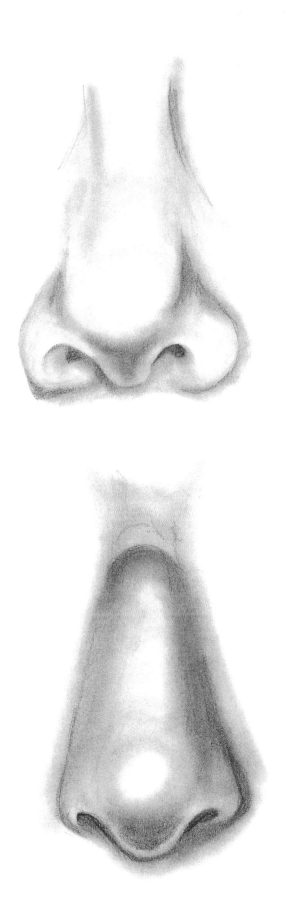

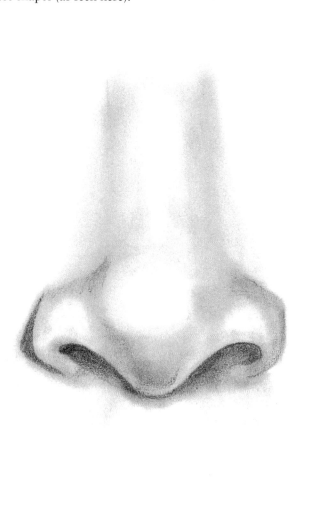

Nostril basics

To get the hang of the nose (if you pardon the expression), study the nostril area. OK, so art isn't as glamorous as you once thought. The size and shape of the nostril help define the shape of the tip of the nose. The more the nostril shows, the more the tip of the nose tends to tilt up; the less the nostril shows, the more the tip of the nose tends to turn down. On some people, you cannot see the nostrils at all.

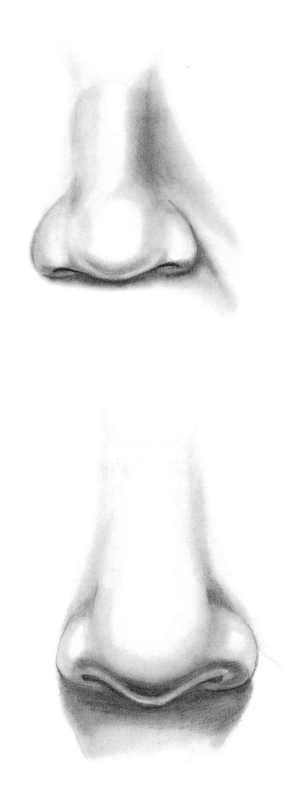

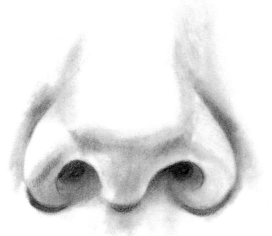

Nostril shapes

The nostrils have differing shapes. Some nostrils are round, some are more triangular and some are quite oval.

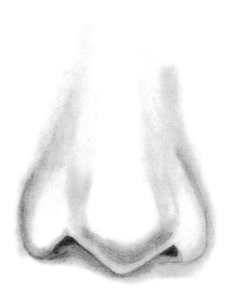

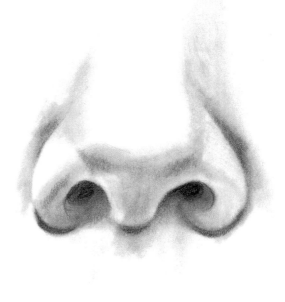

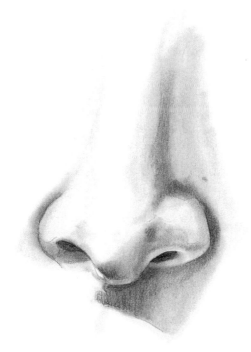

A word about bridges

You've looked at the tip of the nose. Now study the start of the nose, the bridge. The nose begins in the forehead. I know that may seem obvious, but I have seen some drawings where the nose is connected to the eye. Some noses are on the same plane as the forehead. Some noses dip inward at a point below the eyebrows, while others are very flat across the bridge or protrude like the bow of a ship. Artists create all the shape of the bridge of the nose by shading.

Nose tricks

If you identify the shape of the nose high-light, find where the nose picks up the most light and "read" the nose as a series of lights and darks, you will have correctly shaded the nose... up to a point. There are a few tricks to make your nose look more realistic. Many of these tricks involve not drawing the photograph exactly as you see it but adding or subtracting details. The tricks are:

- Seek reflected light.
- Watch the level of nostril darkness.
- Avoid lines.
- Ask yourself questions.
- Link to other features.

Now, look at the man's face again and see if you can you use these tricks to help you make the nose look more realistic.

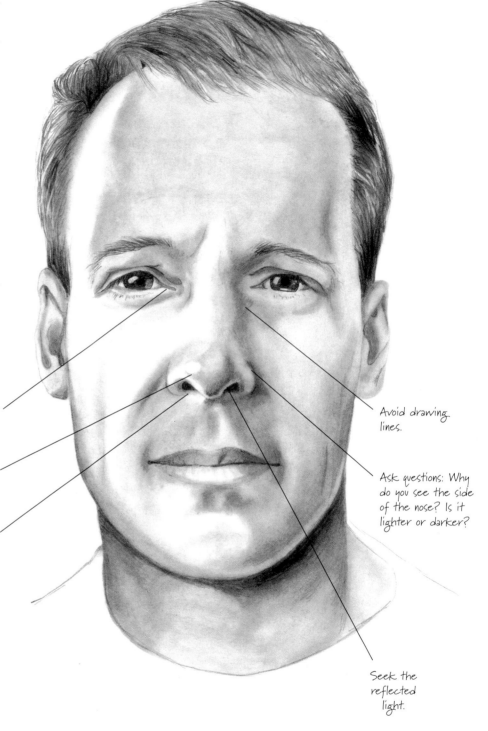

Link to other features.

Place the highlight.

Watch that you don't make this a black hole.

Avoid drawing lines.

Ask questions: Why do you see the side of the nose? Is it lighter or darker?

Seek the reflected light.

Seek reflected light

In chapter five, I reviewed the technique for making something round—I called it "seek." Artists seek to find round patterns and, when discovered, they shade that round object with a specific shading pattern. The tip of the nose is rounded (as in the drawing to the right); if you shade that particular pattern, even if you don't see it, you will have rounded the nose.

Watch the level of nostril darkness

Be careful when you draw the dark areas of the nostril. Two gigantic black holes in the face make viewers feel like they are staring down a shotgun barrel. Even if the photograph shows the nostrils as two black holes, don't get out the 6B lead and darken them in to that level. Make the darkest area near the top, as shown in the lower two drawings, and get lighter toward the bottom.

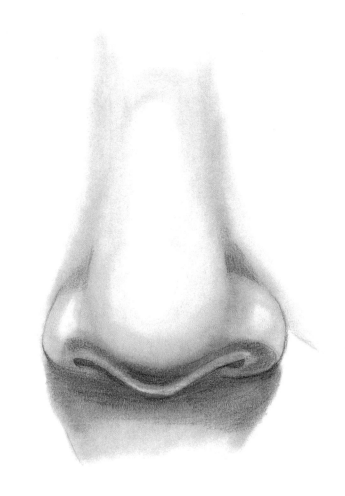

Look at the image on the left; it looks like two black holes rather than nostrils. Compare that to the image on the right, which is shaded more realistically. This just goes to show that shading can make or break your drawing. Keep these images in mind when you go to grab that 6B pencil.

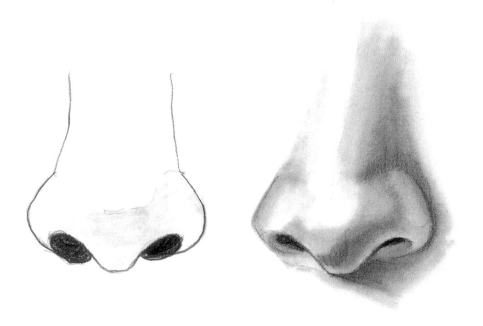

Shade the nose without lines

Get into the habit of never using lines to indicate the side of the nose. Avoiding lines on the side of the nose will limit the temptation to leave them in your completed drawing.

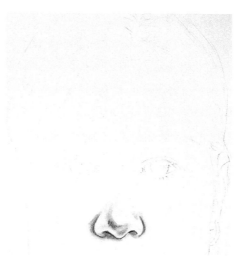

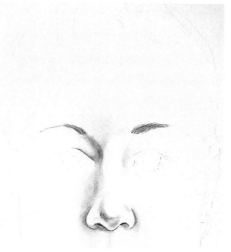

1 Begin with the bottom

Create the bottom of the nose with lines.

2 Blend away the Lines

Shade this area, all the while remembering to blend in the lines of the nose. Resist the temptation to leave them in!

3 Finish the shading

Create the top and sides of the nose with shading only. This will show the distinction between the cheek and nose without using any of those pesky lines.

Ask yourself questions

Ask yourself why you see the various parts of the nose. If two areas are the same shade, your eye cannot separate them, so you can't draw them separate. Lighting varies from photo to photo and face to face. Look at this drawing, study and question the areas of light and dark.

Link to other features

Be sure you link the nostrils, tip, length, direction, general shape of the nose and shading to the other available information on a face. Use the tools presented in the earlier chapters to help you. Remember, your mind is always trying to get the upper hand and tell you what it thinks is true of the art you're working on, not what is visually true.

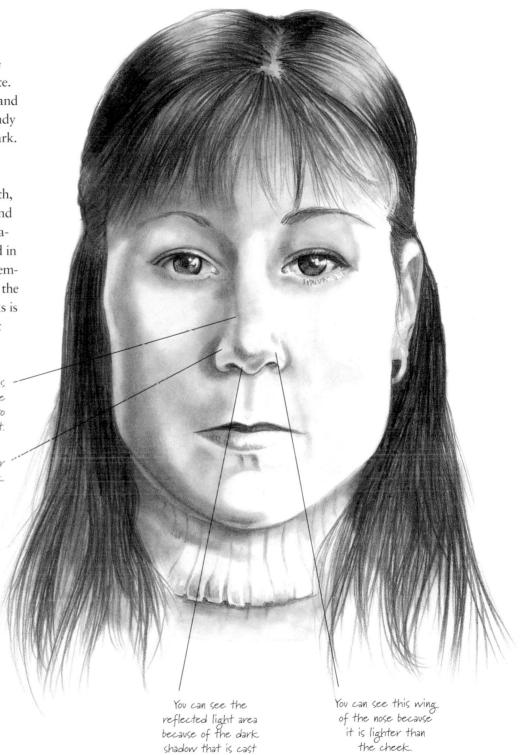

You are able to see this side of the nose because it goes from light to dark, then back to light.

The nose wing is lighter than the cheek.

You can see the reflected light area because of the dark shadow that is cast beneath the nose.

You can see this wing of the nose because it is lighter than the cheek.

Drawing Lips and Teeth

CHRISTIAN EASTERLING
14" × 11" (36cm × 28cm)

Lips are a fairly simple series of shapes. You will quickly notice a line that forms where the upper and lower lip meet. The upper lip looks like a mountain range with two distinct peaks; the lower lip looks basically like a half-circle. You will also quickly notice that a smile effects the other facial features. The lips widen and thin out, the cheeks pucker, the eyes crinkle and the jaw changes.

Teeth, on the other hand, are a real problem for many people. They can be difficult to shade realistically, especially as they move farther back in the mouth. This is also one of the few places you will be able to use some artistic license when drawing the face. If you draw exactly what you see, the hard lines between the teeth will create the appearance a picket fence.

In this chapter, you'll tackle both lips and teeth. I will show you some helpful tricks and techniques to realistically render the mouth and avoid the picket fence look.

Parts of the mouth

The lips can be divided into three major areas of concentration: the upper lip, the line where the lips come together and the lower lip.

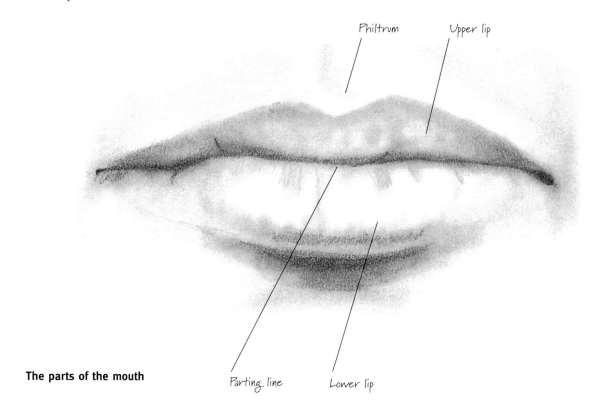

Philtrum

Upper lip

Parting line

Lower lip

The parts of the mouth

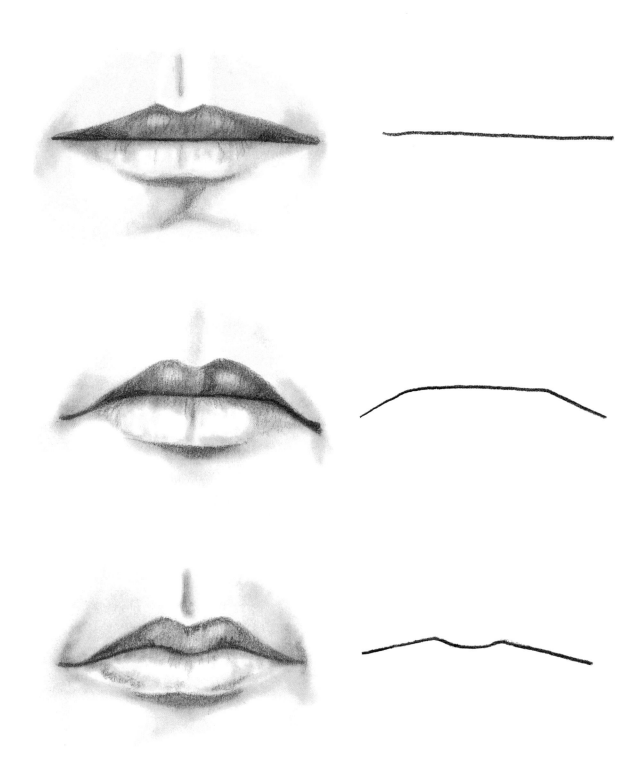

OK, so the face has one line...
I usually start with the line of the mouth. Yes, the mouth is one of the few facial areas that actually contains a line. It is formed from the upper lip and lower lip touching each other. Pay particular attention to this line. Does it go up or down at the corners? Is it straight or wavy? Use a ruler to help you see the direction.

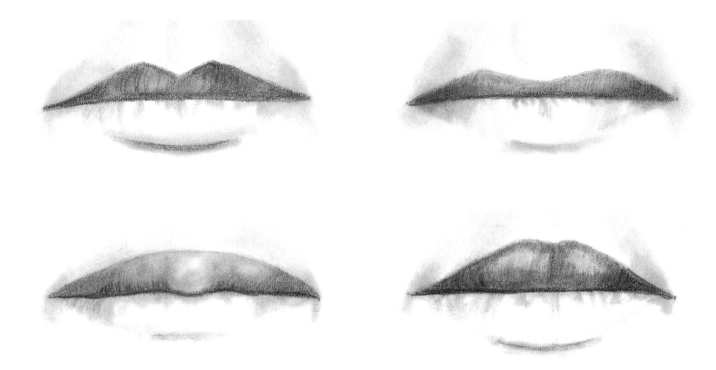

Upper lips

The upper lip is like a mountain range with two mountains. Some people have rolling hills, some have the Rockies and some have the Himalayas. Pay close attention to the location and shape of the two points of the upper lip.

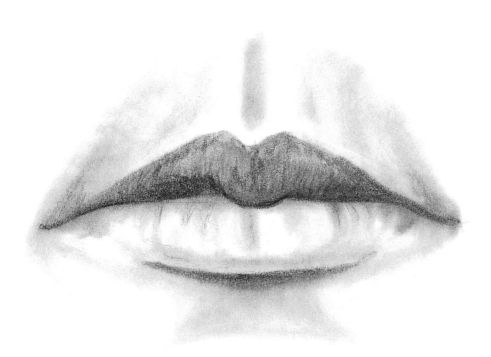

In the groove

The top of the two mountains come to a point at two ridges that extend up to the nose and form a rounded groove called the *philtrum*. Some people have a pronounced philtrum, while on others it is slight.

Lower lips

The lower lip may be equal in size to the upper lip or smaller or larger. Use caution in indicating the lower lip. The top example is the correct way, while the lower example is incorrect. Do not completely outline the lower lip. Remember in chapter five the lower lip was used as an example of a problem area.

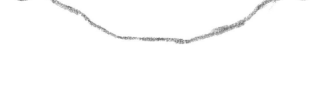

Shading the mouth

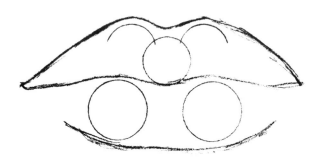

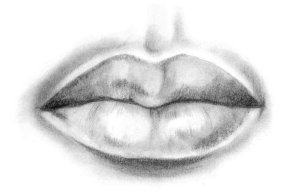

Don't drop the ball

We could, in a manner of speaking, say that the lips contain "five balls," that is, the lips form rounded shapes. These shapes may not appear in many mouths, but if you are sensitive to them, you will seek them when you shade the mouth.

Correct shading

Though upper and lower lips are about the same shade, artists usually shade the upper lip darker than the lower lip. This will help differentiate the two lips and add to the illusion of depth in the work.

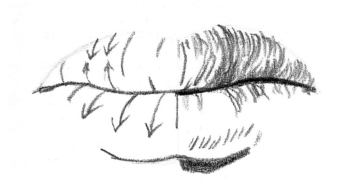

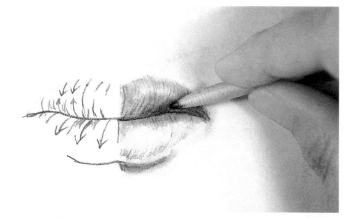

What to look for

Within the lip there are small lines or grooves. Use caution here, as they are usually subtle. Shading in the direction of the lip structure will help you define the roundness of the lips.

Think of a pumpkin

Consider a pumpkin when you shade the mouth. The ribs of the pumpkin help define its roundness. The "ribs" of the mouth help to define the roundness of the lip. This concept of shading something while thinking of the roundness of a pumpkin, is the same for shading mustaches, hair and other features.

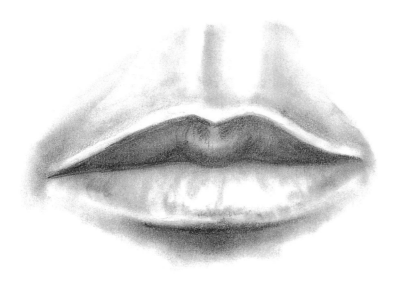

Lip rims

Around the mouth you might see a lighter area caused by a lip rim. This is a narrow area where light is captured around the mouth.

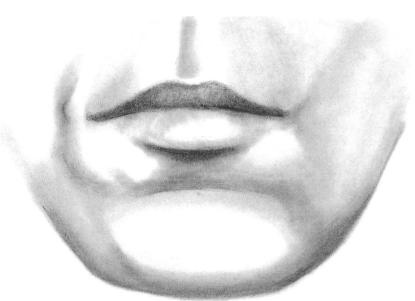

Other mouth shapes

The mouth forms a barrel, or rounded shape, over the teeth. There may be pouches and dips of lighter or darker areas caused by the shape of the underlying teeth, jaw and muscles.

Dealing with teeth

Drawing teeth seems to cause a great deal of grief to some budding artists. This is usually due to the "picket fence effect." They draw each tooth as a separate shape and place hard lines between the teeth.

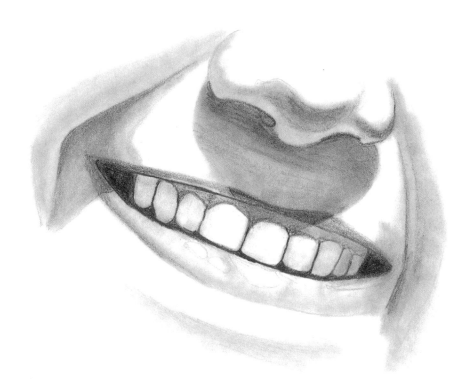

Don't fence them in
If you emphasize the separations between each tooth, your drawing of the mouth becomes distracting and unrealistic.

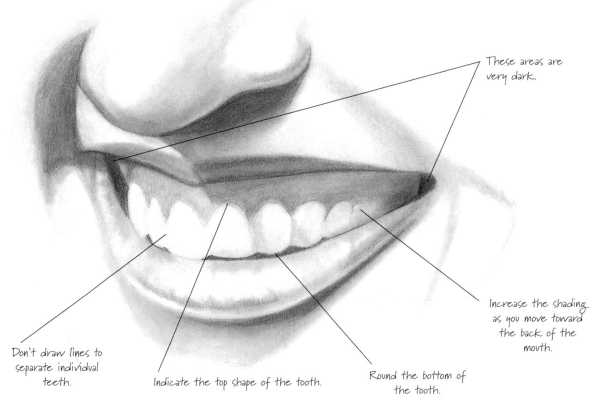

These areas are very dark.

Increase the shading as you move toward the back of the mouth.

Don't draw lines to separate individual teeth.

Indicate the top shape of the tooth.

Round the bottom of the tooth.

Gently, gently
Think of shading teeth as gently indicating the location and shape of teeth, rather than pounding out the details of each tooth. Don't floss the teeth with your pencil. Gradually shade the teeth darker as they go back into the mouth. Then indicate the gum line, add shadows to round the teeth and call it quits.

Smile changes

When a person smiles, not only does the mouth change size and shape, the entire face becomes involved. Eyes pucker, cheeks bulge and the nose broadens and flattens. There is no hard-and-fast rule as to what changes take shape within a smiling face. The important part is to draw what you see using the tools provided.

DETECTIVE CAROLYN CRAWFORD
14" × 11" (36cm × 28cm)

Drawing the Head

I have placed drawing the head toward the end of this book, because I tend to draw from the center of the face outward. There is no hard-and-fast rule on this. In this chapter, you will learn about head shapes and ears. In addition, I'll review the difference between the adult, child and male/female proportions.

In general, I will be teaching you how to draw the head as if you were looking at the person straight on. Obviously, not all drawings will include this angle, but it would be almost impossible for me to include examples of every angle. The best understanding of the basic head shapes will come from the level, straight-on view of the head.

The structure of the head

I have developed a different attitude toward drawing heads ever since I completed a facial reconstruction class by Betty Pat Gatliff. This remarkable woman has spent years teaching (and creating) three-dimensional facial reconstructions. She sculpts with clay directly over the skulls of unidentified people, as shown in the drawing. Handling skulls, even if they're plastic ones you can purchase through art supply stores, is a wonderful way to understand the structure of the face.

Egghead

Generally speaking, people's heads are egg-shaped. The bones and muscles of the face combine to create many different appearances.

Location, location, location

Although faces differ with the underlying bone structure, I seek certain points on the face where "something happens." For example, I know that if the person has prominent cheekbones, the bottom of their cheek will be even with the base of the nose. This is not always the case, but it is an example of certain parts of the face that I check.

Facial reconstruction
Forensic artists have a number of duties, including facial reconstruction or approximation. They start with the skull of an unknown person and attach tissue-depth markers made from an electric eraser (as seen here). This provides the outline of the face.

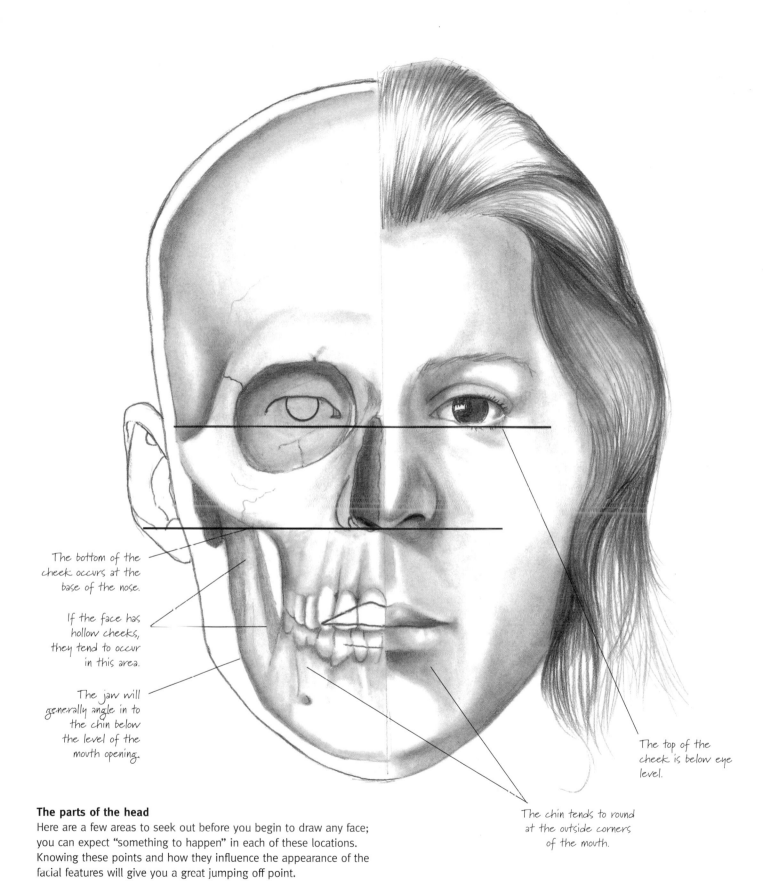

The bottom of the cheek occurs at the base of the nose.

If the face has hollow cheeks, they tend to occur in this area.

The jaw will generally angle in to the chin below the level of the mouth opening.

The top of the cheek is below eye level.

The chin tends to round at the outside corners of the mouth.

The parts of the head

Here are a few areas to seek out before you begin to draw any face; you can expect "something to happen" in each of these locations. Knowing these points and how they influence the appearance of the facial features will give you a great jumping off point.

119

Head shapes

To give you a general idea, I have shown some of the most common head shapes. The shape of the forehead is created by the hairline (or lack thereof). Foreheads may be high, low, rounded, squared or a variety of different shapes.

Round

Long

Oval

Triangular

Rectangular

Cheeks

Cheeks may be prominent, average or
sunken. The cheeks generally start below
the eye and end near the bottom of the
nose.

Prominent

Sunken

Chins

On average, the lower face tends to be divided into three parts between the base of the nose and the chin. The first part is between the nose and the opening of the mouth. The second section is between the mouth opening and the deepest point on the mandible (lower jaw). The third section is between the deepest point on the chin and the bottom of the chin. A chin may be long, short, rounded, square, pointed, double, protruding or receding, or it may have a cleft.

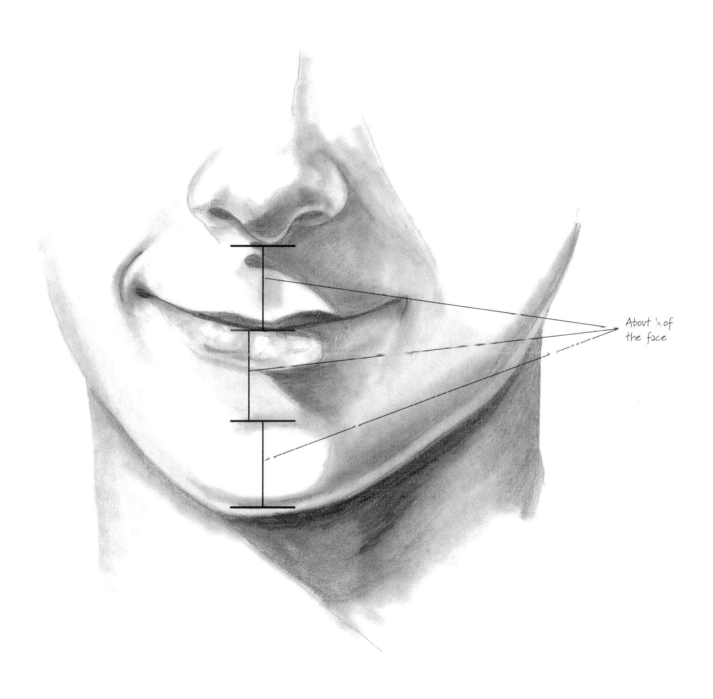

About ⅓ of the face

Necks

Like other parts of the face, necks vary in size and shape. If there is a common mistake that artists make, it is in making the neck too long and thin. The neck begins at the shoulder area and attaches at the chin, but it doesn't end there. It continues up to the ear area, although we usually don't see the entire length when we look at a person straight on. Therefore, check that the length of the neck is in proportion to the angle you are viewing it at. (The neck will appear shorter if you look at it straight on, and longer if you view it from the back.) Clothing fits relatively high up on the neck.

Don't stretch your drawing too thin!
There is one fact that you must remember when drawing necks: You must start them at the shoulder area and continue it up to the ear area. Don't forget to check that the length of the neck is in proportion to the angle you are viewing it at.

The female face

Female faces tend to be more narrow in the chin and jaw area and have a more narrow nose. The eyes are the same width apart as on male faces. Yet, because a female face is more narrow, the eyes may look larger in relation to the rest of the features. Also, the eyebrows tend to be higher and thinner on female faces.

Child vs. adult features

Children have different proportions that change as they grow older (this is especially apparent in the face). The lower face grows and lengthens with age.

This drawing clearly shows how faces can change in appearance as the person ages. Notice how the lower face lengthens, the lips become fuller and hair tends to be less fine. Look at the illustration on the next page for more details that are specific to the faces of children.

DIANA, SHILOH AND AYNSLEE STUART
11" × 14" (28cm × 36cm)

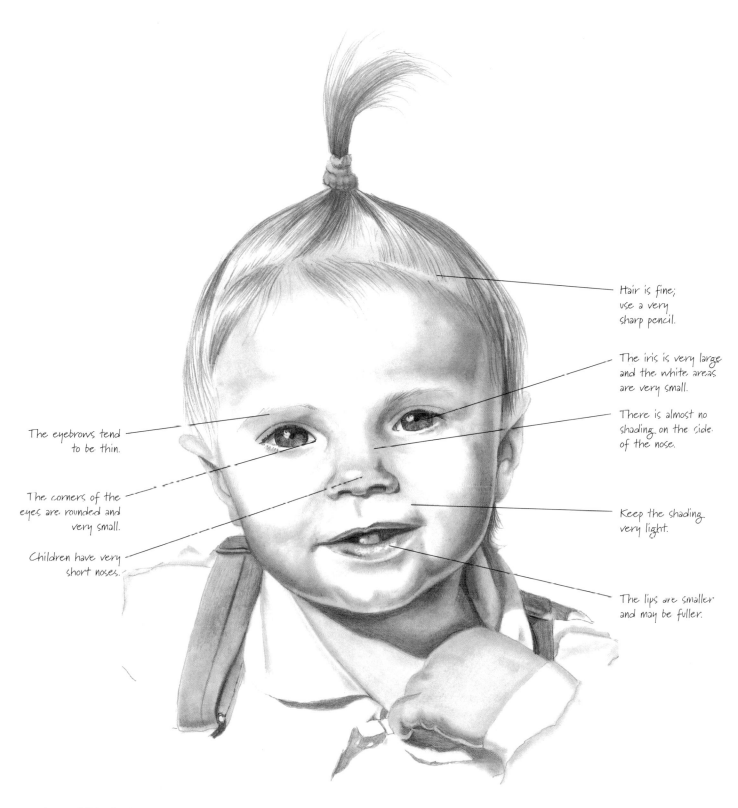

Hair is fine;
use a very
sharp pencil.

The iris is very large
and the white areas
are very small.

There is almost no
shading on the side
of the nose.

The eyebrows tend
to be thin.

The corners of the
eyes are rounded and
very small.

Children have very
short noses.

Keep the shading
very light.

The lips are smaller
and may be fuller.

Drawing a child's face

Many people have trouble making children look young. You need to
be aware of certain secrets when drawing the face of a child. For
example, the child's face should have very little mid-face shading—
especially around the eyes and nose—the iris is very large and the
hair is fine.

Drawing ears

The ears are an important and difficult feature to accurately draw. They are very detailed and vary greatly from person to person.

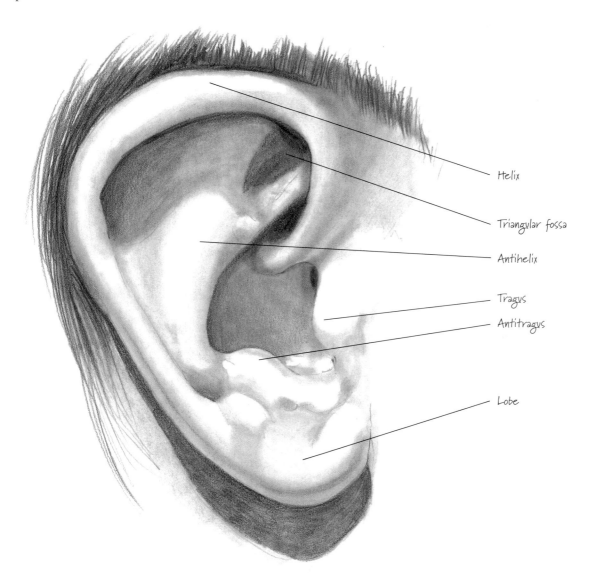

Helix

Triangular fossa

Antihelix

Tragus

Antitragus

Lobe

The main parts of the ear

Learning the parts of the ear early on will save you a lot of grief later; you will always know what parts to look for, no matter how much they may vary from person to person. Plus, you can impress your friends with your in-depth knowledge of ear anatomy!

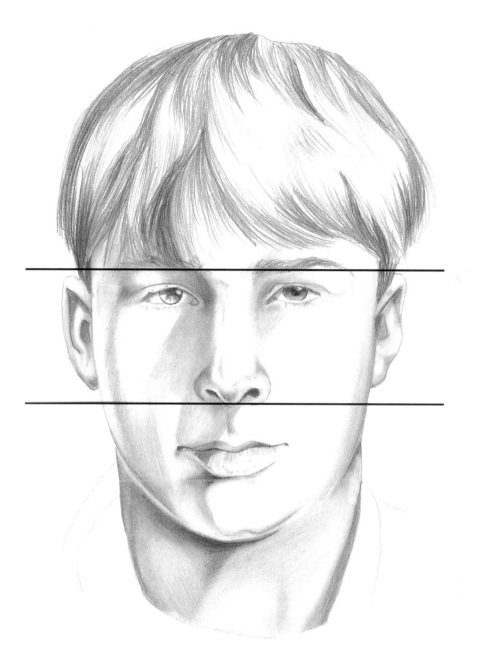

More locations

If you looked at the front of a face, level, you would see that the ears start at the eyebrows and end around the base of the nose. Stated another way, ears are about as long as the nose.

Ears are about as long as the nose.

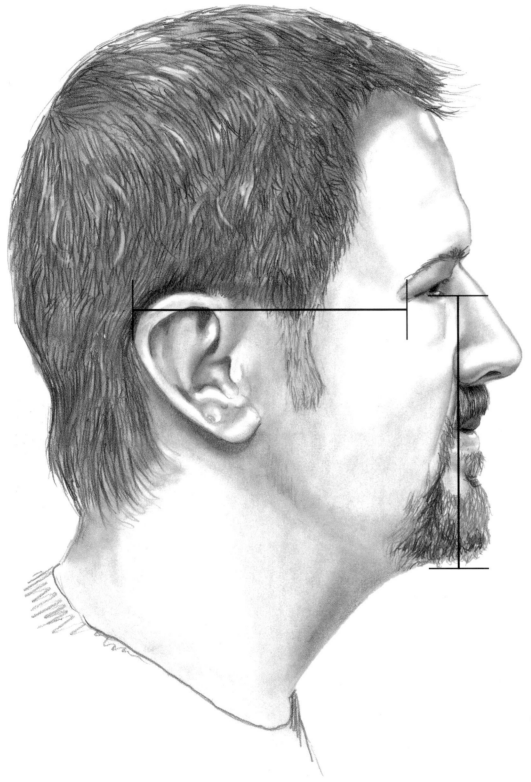

Profile

From the side, the distance from the back of the eye to the back of
the ear is about the same as from the bottom of the eye to the chin.

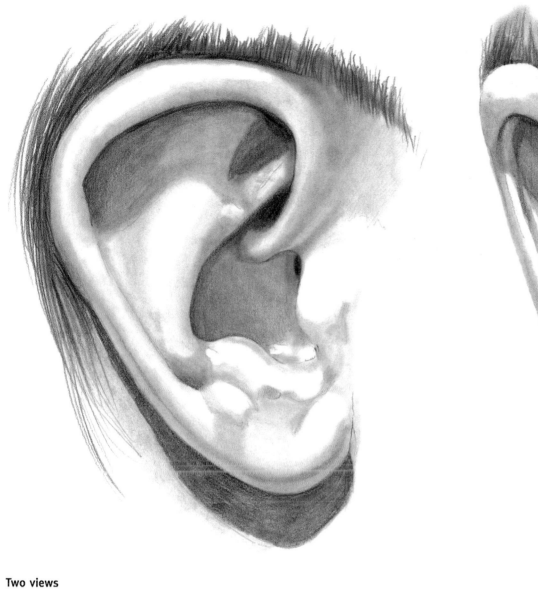
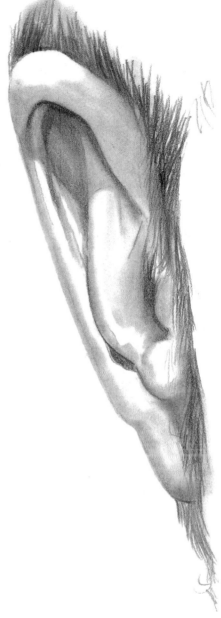

Two views
The ear looks different from the side than from the front.

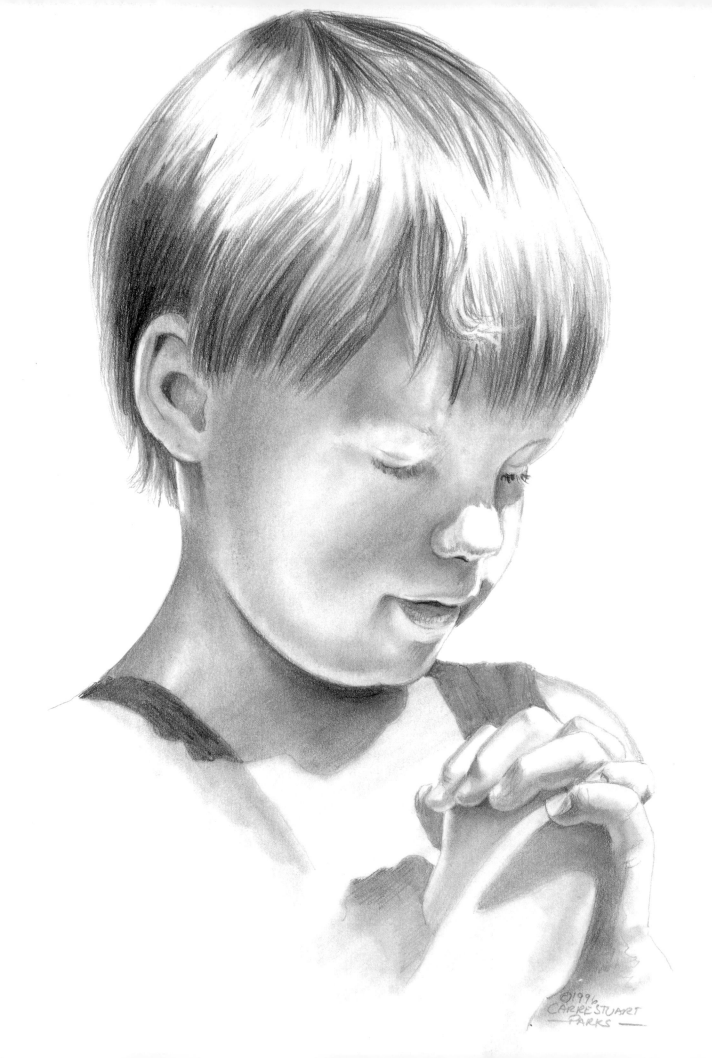

©1996
CARRE STUART
PARKS

Drawing Hair

BENTLEY STUART
14" × 11" (36cm × 28cm)

Drawing hair can be interesting, to say the least. Because there are so many hairstyles, this chapter covers just a few general tricks and techniques.

In order to make "great" hair, you should be prepared to spend some quality time with your pencil; you are going to be at it for awhile.

Dull pencil points make for "flat" hair, not fine hair. Don't just start scribbling somewhere; hair has a start, end, highlights and dark areas. Drawing hair also includes beards and mustaches. You will apply the same principles to facial hair as you did to create the hair on top of the head.

Creating different types of hair

Hair may be fine, coarse, thick or thin, straight or wavy and a host of other appearances. You can draw many of these variables by varying the thickness of the pencil lead and using different grades of lead. Draw thick, coarse hair with a blunt 6B pencil. Use a sharp HB lead for fine hair. Children's hair is usually fine, so make sure your pencil point is sharp.

Combing the hair

As shown in this series of steps, use your pencil to "comb" the hair. Lay your pencil strokes the direction the hair would be growing or combed.

Build darks

Once you establish the direction, start to fill in the strokes. If the hair is fine, do not try to get dark in a single layer of pencil lines. Build the darks by continuing to place more lines in the same place. Start with a very sharp 2H or HB pencil. Progressively move to darker leads (2B-6B).

Pencil lines
A pencil stroke is like a hair—fat at the beginning and fine toward the end.

Create long, dark hair

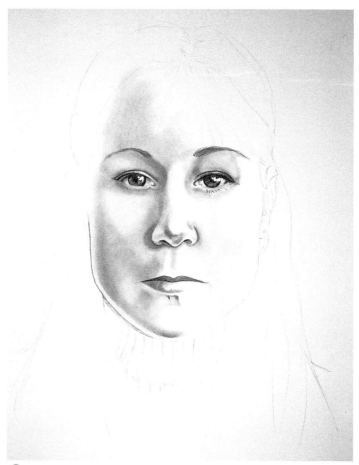

1 Establish an outline

Start by getting the basic information down on paper.

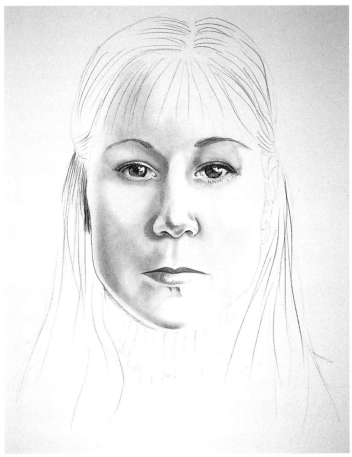

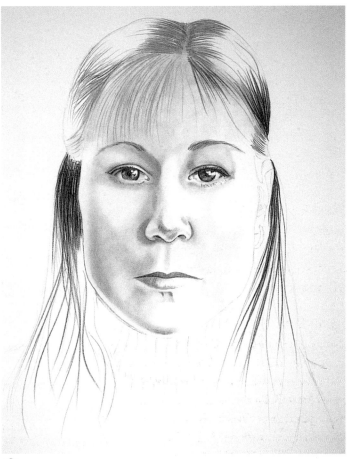

 Start to form the hair

Lay your pencil flat and begin to establish the direction of the hair.

Don't be impatient!

Keep building up the smooth strokes. Hair takes time to accurately render.

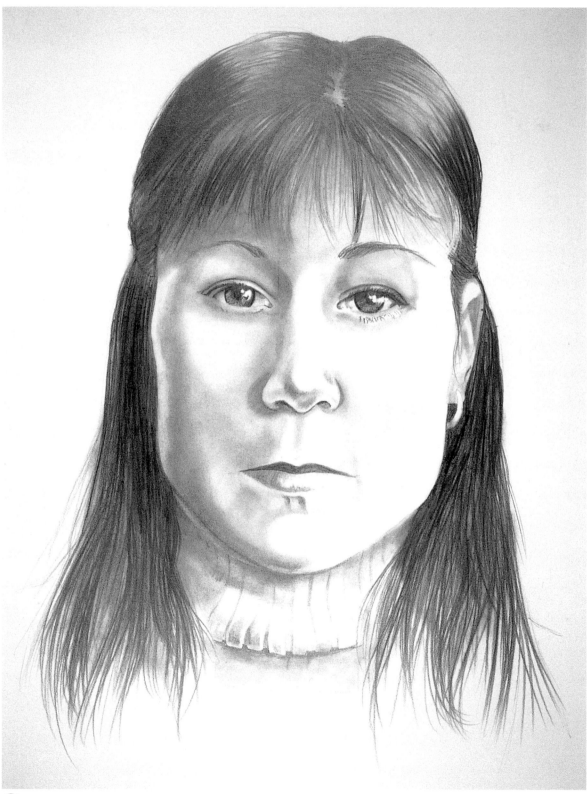

④ Ahh... Finally done!

The end result was definitely worth the wait! Just remember to keep building up your strokes until you hair looks complete.

GINA GAROFANO
14" × 11" (36cm × 28cm)

Build hair highlights

It's better to leave space for the highlights in the hair rather than to try and erase them out. The highlight in the hair should have the end stroke of the pencil coming into it. This means you need to place your pencil lines "backward" into the highlight on the top, as shown in the next four images. Don't leave the highlight a large, white area. Place a line or two completely across the white highlight area.

1 Begin the highlights

Establish the outline of the hair and highlights. Begin to place your pencil strokes back into the highlight. Remember, the end of the stroke should reach into the highlight.

2 Continue to build

Keep layering the strokes and begin to establish the dark and light areas.

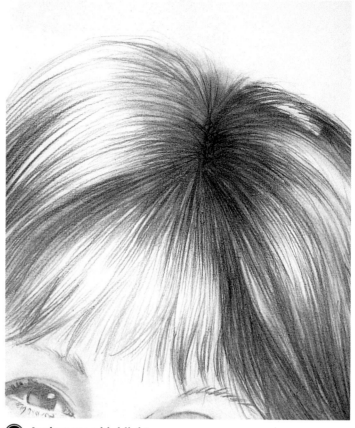

③ Don't forget the light areas

As the hair becomes more defined, check and make sure you are leaving lighter areas for the highlight.

④ Anchor your highlights

Place a few strands across the light areas to blend them into the rest of the hair. This will help save the hair from looking like it has floating white spaces.

Different hairstyles

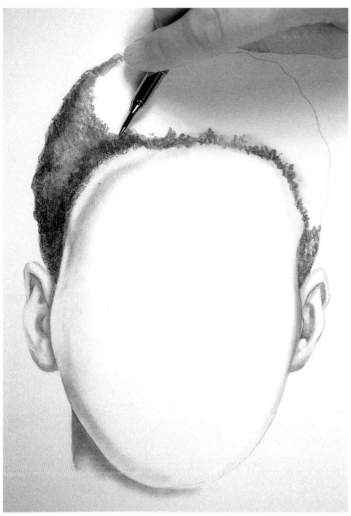

Pencil strokes
You can create some hairstyles by placing a 6B pencil on its side and making very small strokes.

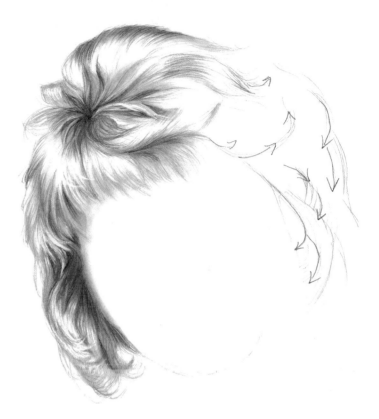

Curly or wavy hair
Treat curly or wavy hair the same as straight hair. Establish the direction of your pencil strokes and where the highlights will occur. Then, settle in for a long afternoon of lines, lines and more lines.

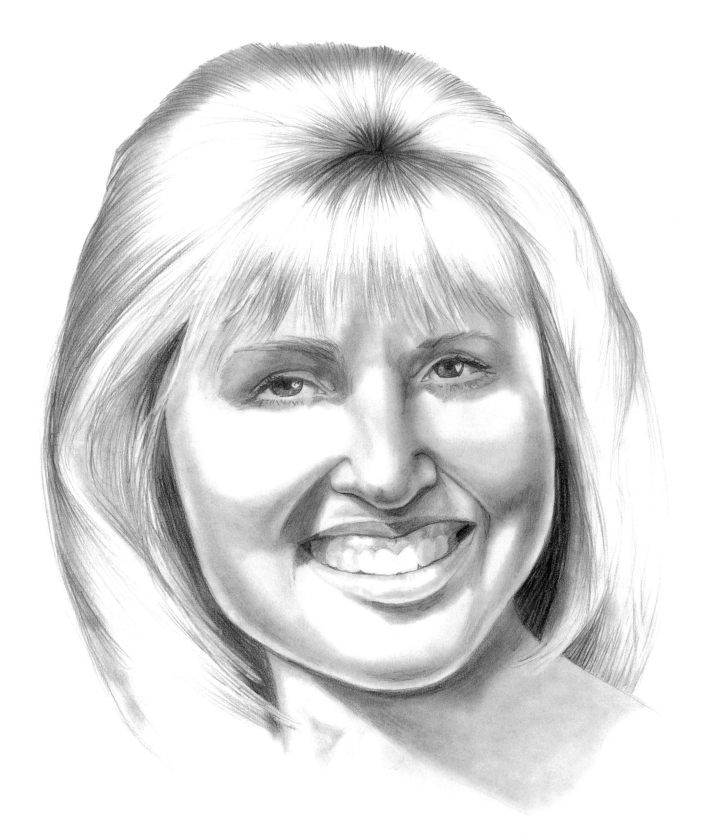

Light-colored hair
Gray or blonde hair will still have dark areas in it. Remember to squint to see those darks.

SUSIE TORONTO, A.K.A. "KUKANA"
14" × 11" (36cm × 28cm)

CONCLUSION

I hope you have arrived at a better understanding of drawing in general and drawing the face in particular. I think drawing is the underlying discipline of all good art. It is the basis which other skills are built upon. Creativity in art is knowledge based—and you now have a great deal of foundational knowledge.

I would love to see any of you in one of my classes some day. I enjoy teaching and seeing you grow as an artist.

I would like to take a bit of time to thank and talk about a number of very special people who have either appeared in this book or allowed me to use their work.

The watercolor appearing in the front is located at the gallery that represents me: Frame of Mind Gallery, 119 N 2nd, Coeur d'Alene, ID 83814 (208) 667-6889. A big hug and thank you to the owners Shane and Merlin Berger. We have been together for a wonderful eighteen years and counting.

John Hinds and Greg Bean are former law enforcement students—and previously untrained artists—who have taken their art well beyond the forensic art field. Both officers have had considerable success in their composite identifications as well. John Hinds is a retired sheriff's detective who currently works as a forensic artist in the New England area. His training in forensic art started in 1989 with extensive training through Stuart Parks Forensic Consultants, then further training with the FBI at Quantico, Virginia. John's composites have been featured in newspapers and news programs, such as "Dateline NBC". One of his drawings led to the identification, arrest and conviction of the worst serial arsonist in U.S. history.

Detective Greg Bean, Bellevue Police Department, Bellevue, Washington, sent me his pre-instructional and the two drawings: "Sunbathing baby Hannah in her daddy's hands. Family reunion, Sturgis, Michigan, August, 2001" and "Cortney from a photograph by Jean at Mount Rushmore, August, 2001."

Taylor Perkins, age 7, is a home-schooled student who attended a special class I offered for home-schooled students.

Kyle and Suzan Helmhout, Hayden Lake, Idaho, attended my class at North Idaho College in Coeur d'Alene. They drew their daughters, Laci, age 1, and Heather, age 5, after four lessons of two hours each.

After a chance, but wonderful, meeting at an art show, I worked out a great working relationship with the talented photographer Kelly Dullanty. Kelly has a couple passions in life: jewelry design and photography. As a gifted designer for over fifteen years, he has created countless jewelry pieces that are works of art in and of themselves and are treasured by their owners. Photography has been a part of Kelly's life for over thirty years, working in the darkroom and casually developing his skills. During the past four years he has taken this passion seriously and has become an award-winning artist in this medium. His portraits and still life studies draw the viewer into the energy of the moment.

The wonderful faces that formed the photographs and drawings: Garrett McDonald, age 12, a rising young artist in North Idaho; Corrine Oberg, a beautiful young lady and aspiring model; Crosby Cross, age 8, a multi-talented young man, Coeur d'Alene, Idaho; Alexis Emery, art student, Coeur d'Alene, Christian Easterling, age 10, a visitor to our ranch and the son of a friend of my brother. Thank you all for your smiling inspiration.

Many law enforcement students agreed to let me turn them into "mugs" for my book and I do owe them a great big "thank you" and a frog sticker. Thanks to Detective Cris Harnisch, Oconomowoc Police Department, Oconomowoc, Wisconsin, Gina Garofano, Poughkeepsie, New York, Detective Carolyn Crawford, Portland Police Bureau and Detective Lieutenant Jerry Scalley, Woburn Police Department, Woburn, MA. Thanks, guys.

Once again I thank my husband, Rick Parks, for his drawing for the book. You have great facial features (your ears, nose, eyes, and profile really helped the cause). You are a brilliant artist, banjo picker and Christian man. What more could I want?

Finally, thank you Susie Toronto, Hayden Lake, Idaho (aka "Kukana"). One talented artist and "Wild, Wacky Woman." Keep it up, girl.

INDEX

A

Accuracy, tools for checking, 24, 25, 74–75
Angles, inclined, 50
Asymmetry, 50

B

Baselines, 30–33
Blending tools, 17
Bone structure and head shape, 118–119
Bridge, of the nose, 101

C

Cartoons, 25
Centering eyes, 80
Cheekbones, 119
Cheeks, 38, 122
Children's head shapes, 126
Chins, 119, 123, 125
Circles, shading, 71
Color of eyes, 87, 88
Color of hair, 140
Comparing value changes, 68
Composite drawing, 10
Computers, as drawing aides, 68
Contrast, within the iris, 87
Curly hair, 139
Curves
 cheek, 122
 of eyebrows, 93
 measuring, 38

D

Darkness, 105, 134
Distance, and accuracy, 74

E

Ears, 128–131
Electric pencils, 14
Enlarging, 36–37
Erasers, 15–16
Expression
 and eyes, 82–84
 and facial feature change, 115
Eyebrows, 89–93
Eyelashes, 89–93
Eyes, 78–93
 children's, 127

and expression, 82–84
and eyelids, 85–86
and iris location, 46–47, 48, 80
measuring their location, 35, 78–79
in various shapes, 89–90

F

Facial features
 checking subtle angles of, 50
 and curves, 38
 measuring their location, 34–35
 and optical indexing, 39–40
 and shading based on shape, 71–73
 See also specific feature name
Facial reconstruction, 9, 118
Female faces, 97, 125
Flattening to two-dimensions, 57
Foreheads, and nose placement, 97

G

Gender, and facial differences, 97, 125
Graphite, 14
Grid rulers, 50
Grids, 40

H

Hair, 134–140
 children's, 127
 eyebrows and eyelashes, 89–93
 highlighting, 137–138
 shading, 112
 styles, 139–140
 texture, 134–135
HB lead, 14
Head shapes
 and bone structure, 118–119
 child vs. adult, 126–127
Highlighting
 eyes, 87, 88
 hair, 137–138
 noses, 102
Holders, lead, 14

I

Inclined angles, 50
Indexing, optical, 39
Inverting images, 49, 74

Irises
 measuring, 47, 48
 and pupil placement, 80
 shading, 87–88
Isolating shapes, 45, 68

J

Jaws, 119, 123, 125

K

Kneaded rubber erasers, 15–16

L

Lead, grades of, 14
Light
 and changes in value, 60
 and feature visibility, 105
 and shading of eyes, 88
 and shading of lips, 113
 and shading of noses, 102
Lines
 avoiding on noses, 104
 of hair, 134
 killing, 65–66
 of the mouth, 67, 109, 112
 and value change, 64
Lips. See mouths
Location. See site
Long head shape, 120
Lower eyelids, 86
Lower lips, 67, 108, 111

M

Male noses, 97
Materials
 for drawing eyes, 79
 erasers, 15–16
 for measuring, 33, 37
 paper, 17
 pencils, 14
 templates and blending tools, 17
Measuring
 chins, 123
 curves, 38
 ear location, 129–130
 eyes, 48, 78–79
 proportions, 30

tools for, 37
Mechanical pencils, 14
Memorization, 21
Mirror technique, 75
Mouths, 108–113
 children's, 127
 and lines, 67, 109
 and lip shape, 110–111
 shading, 112

N

Necks, 124
Negative space, 51, 52
Noses, 96–105
 children's, 127
 and ears, 129
 female, 125
 placement of, 98
 and shape of nasal wings, 99
Nostrils, 100–101

O

Optical tools, 39
Outlines, 26
Oval head shape, 121

P

Paper, 17
Paper stump, 60
Patterns, perceived
 breaking, 24
 and untrained drawings, 20–23
Pencils
 and eye color, 88
 handling of, 61
 and lead grades, 14
 and measuring proportions, 32–33, 35
Perception
 questioning, 53–54
 testing the accuracy of, 74
 and untrained drawings, 20–23, 24
Philtrum, 108, 111
Photographs
 and checking subtle angles, 50
 and establishing baselines, 30–31
 as references, 44
Pointers, lead, 14

Positive space, 51, 52
Pre-instructional drawings, 19–22
Proportional divider, 37
Proportions
 enlarging, 36–37
 of iris to eye, 47
 measuring, 30–33
 and use of grids, 40
Pupils, 46–47, 80

Q

Questioning perception, 53–54, 69

R

Rectangular head shape, 121
References
 choosing the right, 44
 importance of using, 24
 and measuring baselines, 30–33
 reflected light, 103
Renaming, 50
Round shapes
 of heads, 120
 within the jaw, 113
 within the lips, 112
 shading of, 71, 103
Rubber erasers, 15
Rulers, 15, 50

S

Scale, of values, 68
Seeing, drawing as, 20, 24
Shading, 60–73
 children's faces, 127
 defined, 24, 25
 of eyes, 87
 limited to visible value changes, 68–69
 and lines, 64–67
 of lips, 67, 112
 of noses, 101, 103–104
Step-by-step techniques for, 62–63
 of teeth, 114–115
 shape, 44–57
 defined, 24, 25
 of eyebrows, 92–93
 of eyes, 47–48, 78–79
 flattening, 57

of heads, 118–121
 of noses, 96, 99, 101
Shading and, 71–73, 103
Sharpeners, pencil, 14
Shields, for erasing, 16
Simplification, 46
Site, 30–41
 defined, 24
 and enlarging, 36–37
 and measuring proportions, 30–33
 of noses, 97, 98
 and optical indexing, 39–40
 and the pencil technique, 34–35
 See also measuring
Skin texture, 61
Smiles, 115
Smudging, 60–61
Squinting, 68, 140
Symmetry, 50

T

Techniques of feature assembly, 24–26
Teeth, 114–115
Templates, 17, 79
Three-dimensional subjects
 flattening to two-dimensions, 57
 and measuring baselines, 32–33
Tortillion, 17
Tracing, 55–56
Triangular head shape, 121
Two-dimensional references
 and checking subtle angles, 50
 establishing baselines in, 30–31
 flattening objects to, 57

U

Upper lips, 67, 108, 110, 111

V

Values
 changing, 60
 and lines, 64
 scale of, 68
Viewfinders, 51

W

Wings of the nose, 96, 98–99

Learn how to render the male and female human form in a classic style! Clem Robins makes it easy by combining direct observation of the human form with an analytical study of anatomy, perspective, light, shade, and composition. Each chapter includes explanatory text, plus annotated drawings or step-by-step demonstrations.

ISBN-13: 978-1-58180-204-7
ISBN-10: 1-58180-204-8, PAPERBACK, 144 PAGES, #31984

A bestseller for three decades, this extraordinary book shows you how to reduce complex figures into a variety of easy-to-draw shapes. It's a powerful combination of classic, proven instruction, detailed anatomy studies examining bone and muscle structure, and special guidelines for drawing the head, hands and feet.

ISBN-13: 978-0-89134-097-3
ISBN-10: 0-89134-097-1, PAPERBACK, 144 PAGES, #7571

Bert Dodson's successful methods of teaching have made this book one of the most popular, best-selling art books in history! He provides a complete system for developing drawing skills, including 48 practice exercises, reviews, and self-evaluations. Topics include learning to control proportion, scale, movement, depth, pattern, and more!

ISBN-13: 978-0-89134-337-0
ISBN-10: 0-89134-337-7, PAPERBACK, 224 PAGES, #30220

The key to creating a likeness is to see and draw the big shapes of dark and light. This book makes it easy. In nine step-by-step demos, you'll learn how to master basic drawing techniques, render facial features and expressions, then draw a variety of people in different poses and lighting conditions.

ISBN-13: 978-1-58180-245-0
ISBN-10: 1-58180-245-5, PAPERBACK, 128 PAGES, #32023